IN AND OUT OF PLACE:

CONTEMPORARY ART AND THE AMERICAN SOCIAL LANDSCAPE

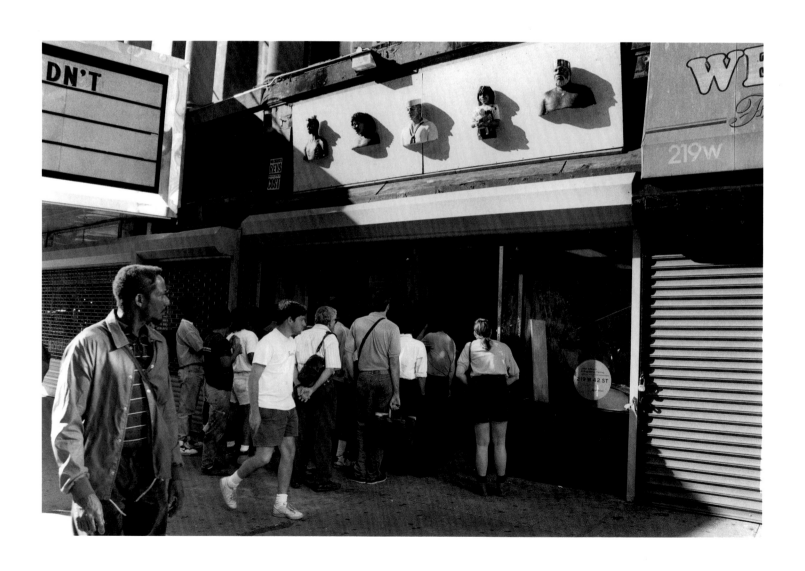

IN AND OUT OF PLACE:

CONTEMPORARY ART AND THE AMERICAN SOCIAL LANDSCAPE

Trevor Fairbrother and Kathryn Potts

Museum of Fine Arts, Boston

Copyright © 1993 by the Museum of Fine Arts, Boston
Library of Congress Catalogue Card Number 93-079743
ISBN 0-87846-403-4

Designed and typeset by Janet O'Donoghue
Edited by Cynthia M. Purvis
Manuscript and photography coordinated by Kathi Drummy
Printed in U.S.A. by Meridian Printing, E. Greenwich, Rhode Island
Bound by Acme Bookbinding Co., Charlestown, Massachusetts

Cover

Diane Arbus. American, 1923-1971. *A Castle in Disneyland, California*, 1962. Photographic print (printed by Neil Selkirk, 1973). Sheet size: 19⅞ x 15⅞ inches; image size: 14¼ x 14¼ inches. Museum of Fine Arts, Boston, Polaroid Foundation Purchase Fund 1973.565

When Arbus photographed the Castle at Disneyland, she intuitively cast sadness and shadows on an icon of sentimental optimism. Dedicated in 1955, Walt Disney's Magic Kingdom in Anaheim, California, was instantly profitable. Depending on one's perspective, the Disney theme park might be fun and mindlessly diverting, exhilaratingly camp, or depressingly tacky. Devoid of tourists and Disney "inhabitants," Arbus's nighttime shot confronts the hollow reality of this uniquely American desire to make a clean and commercial "world of make believe."

Frontispiece

Exterior of John Ahearn and Rigoberto Torres's 42nd Street Sculpture Workshop at 219 West 42nd Street, July 1993

Exhibition dates:
Museum of Fine Arts, Boston
October 19, 1993–January 23, 1994

The exhibition was organized by the Museum of Fine Arts, Boston, and was made possible by AT&T NEW ART/NEW VISIONS.

Additional support was provided by the Estate of Edythe Andrews.

The catalogue was made possible by The Andy Warhol Foundation for the Visual Arts, Inc.

CONTENTS

FOREWORD

In recent years, America's art museums have begun to respond to the needs of racially and culturally diverse populations. This process has been slow and sometimes difficult, for we live in a period of dissent, and the forces of change are countered by traditionalism and censorship. Not surprisingly, living artists and contemporary art are at the center of this national debate. Here, at the Museum of Fine Arts, Boston, the Department of Contemporary Art has embraced these changes. This historic institution is learning that this commitment can be controversial—for example Jenny Holzer's *Truisms*, flashing over the entrance to the Foster Gallery, are not everybody's "cup of tea"—but I believe it is our responsibility to reflect the pressing issues of contemporary life. In fact, presenting new art and working with living artists has been part of the Museum's stated mission since it opened in 1876.

This exhibition was organized by Trevor Fairbrother, the Robert L. Beal, Enid L. and Bruce A. Beal Curator of Contemporary Art, and by Kathryn Potts, curatorial assistant in the Department of Contemporary Art. I am delighted that they received a grant from AT&T NEW ART/NEW VISIONS, an innovative corporate program devoted to forward-looking art and ideas. With the funds provided by AT&T, the Museum has organized this exhibition, planned an artist-in-residency program with local high school students, and acquired a work by one of the artists in the exhibition. A bequest to the Museum of Fine Arts from the estate of Edythe W. Andrews provided matching funds. The Democ-

racy Wall by Group Material was supported in part by the Charles Engelhard Foundation.

The Andy Warhol Foundation for the Visual Arts, Inc., gave a generous grant to produce this book, which explores the complicated issues raised by "In and Out of Place: Contemporary Art and the American Social Landscape."

Finally, I am indebted to the artists who agreed to participate in the exhibition and to all the lenders who generously shared their objects.

ALAN SHESTACK
Director

ACKNOWLEDGMENTS

This exhibition would not have been possible without the enthusiastic support of all of the artists and their galleries: John Ahearn; Brooke and Caroline Alexander and Ted Bonin; Doug Ashford, Julie Ault, and Felix Gonzalez-Torres of Group Material; Tina Barney; David and Jan Bates; John and Gretchen Berggruen; Janet Borden; Y. David Chung; Charles Cowles; Mary Sabbatino of Galerie Lelong; Komei Wachi of Gallery K; and Krzysztof Wodiczko.

At the Museum of Fine Arts, Director Alan Shestack endorsed this project from its inception. In the Department of Contemporary Art, Kathi Drummy, operations coordinator, deftly managed the catalogue and the loans. Her expertise, humor, and diligence were invaluable to every aspect of this project. We are also grateful for the contributions of our colleagues at the Museum of Fine Arts. Janet O'Donoghue and Cynthia Purvis designed and edited this catalogue. Chief exhibition designer Michael Rizzo worked with us and the artists to make the exhibition design and installation. David Moffatt, Sally Keeler, and the entire crew made the exhibition a reality. Barbara Martin of the Education Department helped write the interpretative materials. Désirée Caldwell and her staff in Exhibition Planning—Joshua Basseches and Jennifer Wells—oversaw the administration and organization of the show. In the Registrar's Office, Patricia Loiko and Jill Kennedy-Kernohan arranged the shipment of all the loans for the exhibition, including the few late additions. Martha Reynolds, of the Development Department, worked on both of the grant proposals that funded this catalogue and exhibition. Irene Konefal and Patricia O'Regan of Paintings Conservation, Roy Perkinson and Annette Manick of Paper Conservation, and Margaret Leveque of the Museum's Research Laboratory provided expertise and advice.

The Department of Photographic Services played an important role in the production of the catalogue, especially Tom Lang, who oversaw the new photography for the book as well as the photography of Y. David Chung's installation at the Wadsworth Atheneum. We would like to thank Janice Sorkow and her staff, in particular Deborah Squires, for coordinating the in-house photography and duping of photographic materials. Museum photographers John Lutsch, Gary Ruuska, and John Woolf worked on the catalogue project. Robert Mitchell and Jennifer Smith coordinated the publicity for the exhibition. Karin Lanzoni, of the Museum's William Morris Hunt Memorial Library, was enormously helpful to our research. Lorri Berenberg, Margaret Burchenal, Peter Masciarotte, and Bradley Rubenstein created the accompanying educational program and artist's residency program. Joan Harlowe and Laurie Thomas planned public lectures and gallery talks. Mark Wise, coordinator of Audio-Visual Services, oversaw the video works in the exhibition. Laura Baptiste, David Dologite, Randi Hopkins, and Antien Knaap, interns in the Department of Contemporary Art, all provided research and editing support for the catalogue.

Warm thanks are also due to the following individuals at other institutions who generously contributed their time and assistance to this project: Jennifer Huget, Christy Fisher, and Monique Shira of the Wadsworth Atheneum; Peter Boswell of the Walker Art Center; James Kelly and Mark Fletcher of Laura Carpenter Fine Art; Lynn Herbert of the Contemporary Arts Museum, Houston; Don Quaintance of Public Address Design; Ron Clark at the Whitney Independent Study Program; May Castleberry, librarian at the Whitney Museum of American Art; and Michele Furst of the Visiting Artist's Program of the Massachusetts College of Art. We owe thanks to many people for their assistance in locating photographs for the catalogue—special mention is due to Celeste Coughlin, Brooke Alexander Gallery; Gabrielle Maubrie, Galerie Gabrielle Maubrie; Cécile Panzieri, Galerie Lelong; and Anna Ramis, Fundació Antoni Tàpies.

We would like to thank Timothy McClimon and Liane Thatcher for inviting us to submit a proposal to the AT&T NEW ART/NEW VISIONS program. Special mention is due to Fred Schroeder and Lisa B. Cohen of Resnicow Schroeder Associates for coordinating the national publicity campaign for AT&T. We are also indebted to The Andy Warhol Foundation for the Visual Arts, Inc., in particular Pamela Clapp and Emily Todd, for the generous grant that allowed us to publish this book. Charlene Engelhard and the Charles Engelhard Foundation provided crucial support of Group Material's Democracy Wall. Lastly, we salute the numerous lenders to the exhibition without whom this project would not have been possible.

T.F. and K.P.

PREFACE

In 1991 the Department of Contemporary Art at the Museum of Fine Arts, Boston, was invited to submit a proposal for the new funding initiative AT&T NEW ART/NEW VISIONS. The AT&T Foundation contacted fifty art institutions regarding this three-tiered challenge grant to help sponsor an exhibition of contemporary art, a corresponding education program, and the purchase of a work of art created by an artist featured in the exhibition. The larger goal identified in the guidelines was to heighten public awareness of contemporary art in American art institutions by encouraging them to present new and recently created work, and to work with women and artists of diverse cultures. In 1992, an advisory committee chose the Museum of Fine Arts, Boston, and nine other institutions to receive AT&T NEW ART/NEW VISIONS grants.

The group exhibition "In and Out of Place: Contemporary Art and the American Social Landscape" has been created in response to this grant. From the outset Kathryn Potts, curatorial assistant, has worked with me as collaborator and co-organizer for the project. Our objective was to examine the predicament of diverse individuals, classes, and populations in the United States as we saw it reflected in recent art. Our method was to find visually compelling works that directly or indirectly touched on social issues from different perspectives. The five artists and one artists' collective finally chosen for the exhibition do not share a common aesthetic or social agenda; if asked "In what way is social concern a motivation for your work?" their answers would differ considerably.

In the two years since we wrote the initial grant proposal we have tightened the critical concept for the exhibition and adjusted and revised the title and the list of artists. The project began with the working title, "Boundaries: Confronting People and Place." In the grant proposal we spoke of "the relationship between individual figures and the surrounding cultural, social and political landscapes," and hoped that the conjunction of different artistic voices on this general theme would raise awareness and spark new observations. It was always our intention to juxtapose works in a variety of media. As the focus of the exhibition developed, the metaphor of the boundary gave way to a more pointed use of the word "place," meaning the real or emblematic settings that people inhabit. The words "in and out of place" are intended to encourage the viewer to ask such questions as: Who is in the picture and who isn't? Who seems to belong there and who doesn't? Whose voice is being heard? All of the art in the exhibition references particular places and individuals. When presented together it is hoped that the collective impact will provide an opportunity to reflect upon pressing social issues with the distance that art provides, for better or worse. This exhibition is not an exhaustive treatment of the topics it addresses. It can be noted that Native-American or African-American artists are not represented; and many pertinent issues are not addressed directly by any of the work. Finally, as in any exhibition, the selections that were made involved the subjective choices of the curators.

A generous grant from The Andy Warhol Foundation for the Visual Arts, Inc., made it possible to produce a catalogue to accompany the exhibition. This publication provides the opportunity for a detailed scholarly consideration of the artists and the insights afforded by their works. Inspired by the art in

the exhibition, the catalogue seeks to foster dialogue on issues of social and cultural concern in the U.S. today. Topics of particular concern include: the social crisis of the American city; the class system and the marginalization of homeless people; the question of assimilation confronting immigrants; and the difficulty of representing the multicultural reality of American life. The book is structured as follows: the first section introduces each of the artists, with biographies and illustrations of their work; the second section presents two essays; finally there is an exhibition checklist and bibliography.

TREVOR FAIRBROTHER
Beal Curator of Contemporary Art

Krzysztof Wodiczko. Drawing for *Poliscar*, 1991. Graphite on vellum. 30 x 53 inches. Courtesy of Galerie Lelong, New York

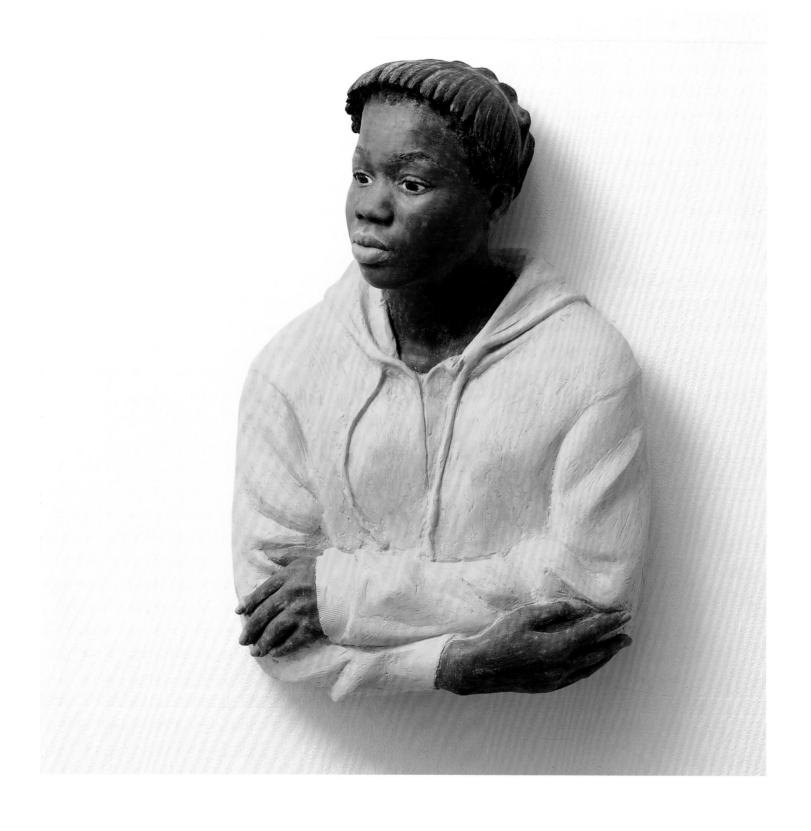

John Ahearn

1951 Born in Binghamton, New York

1973 Receives B.F.A. from Cornell University, Ithaca, New York; moves to New York

1976 Becomes involved with Colab (Collaborative Projects, Inc.), a group of young socially engaged artists

1979 First solo exhibition, South Bronx Hall of Fame, held at Fashion Moda, Bronx, New York. Begins his collaboration with Rigoberto Torres

1980 Co-organizes and participates in the Times Square Show—a historically important group exhibition in an abandoned massage parlor in midtown Manhattan. Moves from East Village to South Bronx

Current Maintains a studio and residence in South Bronx, New York City

Ahearn is a sculptor who casts the faces and bodies of friends and neighbors and uses them to make vivid portraits. He grew up in Binghamton, where his father was a doctor. He attended boarding school in New Jersey, then studied at Cornell University; there he made portrait drawings in local nursing homes, bowling alleys, and elementary schools. He also painted outdoors. After college Ahearn moved to SoHo and made abstract paintings. He later became involved with the artists' group,

< *Takiya*, 1990. Acrylic on cast plaster. 25 x 18 x 7½ inches. Courtesy of Brooke Alexander, New York

Colab (Collaborative Projects, Inc.), helping to film their local TV broadcast, "All Color News," and participated in their thematic exhibitions on such varied topics as dogs, dentists, real estate, and Batman.

Ahearn's move to sculpture occurred serendipitously in 1979: he was making a monster movie and was inspired by a book on make-up techniques for film and television to try life casting. Excited by these experiments, he decided to make this his art form. Life casting is a two-step process: first, a mold is made from the human body; from this mold a three-dimensional plaster sculpture is cast. Ahearn makes a mold of the subject's face and upper body with alginate, a non-sticking jelly that dentists use to take tooth impressions. Covered in gel, and breathing through straws inserted in the nostrils, the intrepid subject must lie patiently for about twenty minutes until the mold sets. Because there is no turning back once the alginate is poured, Ahearn and the subject must choose the pose and expression before making the mold. Later, Ahearn carves and elaborates additional details and paints the colorless plaster form, referring back to Polaroids taken the day of casting.

Ahearn developed his process and style in the late 1970s, in sync with New Wave and Punk counterculture. Like other socially engaged artists, he was eager to make work that stepped beyond the confines of the elitist art world to address large, heterogeneous communities. Many in his generation turned away from the tradition-bound, commercially oriented network of galleries and museums in favor of the informal, artist-run spaces that proliferated on the fringe of the art world. His twin brother, film and video artist Charles Ahearn, proposed Fashion Moda (a new "alternative space" in the South Bronx) as a place where John could make a project for an inner-city community. There in 1979, he presented an exhi-

Ahearn casting Janel Evans at Dawson Street Studio, 1983

a community occasion, often setting up a sculpture workshop on the street for all to see.

Ahearn's early cast portraits struck some critics as a welcome and lively antidote to the esoteric, abstract, and conceptual work that had prevailed for a decade. Whether the subject strikes him as exuberant, content, quiet, or reserved, Ahearn seeks to mirror each person's strength and dignity. The sculptures of the American realists George Segal (born 1924) and Duane Hanson (born 1925) were precedents for Ahearn's use of life casts: Segal favored monochrome surfaces that abstracted and generalized his subjects, while Hanson emphasized meticulous details so that his dressed and accessorized figures are easily mistaken for real people. Ahearn has taken yet another approach, relying on summary, broadly brushed painted surfaces to enliven his objects. He uses paint to counter traditional sculpture's inherently static condition and to evoke the energy and presence of his sitters. As important as these formal concerns are for Ahearn, he also sees himself as a kind of performance artist whose work is produced with and for the community.

When Ahearn moved to the South Bronx in 1980 he started to work with Rigoberto Torres. He had met and cast the young Puerto Rican a year earlier, when Torres was still in high school. Torres had extensive knowledge of casting techniques

bition with the witty and populist title "The South Bronx Hall of Fame." In it Ahearn showed about forty new portrait sculptures of people from the neighborhood, many from the methadone clinic across the street. The artist offered to make a cast of any passersby who were intrigued by what they saw in the storefront window. Over the years Ahearn and his collaborator, Rigoberto Torres, have turned the mold-casting event into

> *Raymond and Freddy*, 1992. Acrylic on cast plaster. 32½ x 24 x 9¾ inches. Museum of Fine Arts, Boston. Purchased through funds provided by AT&T NEW ART/NEW VISIONS and the William E. Nickerson Fund

The Garcia brothers live on Walton Avenue near the artist in the South Bronx. Freddy (in white shirt) is HIV positive. His brother Raymond has been cast several times and also posed for Ahearn's Bronx Sculpture Park project.

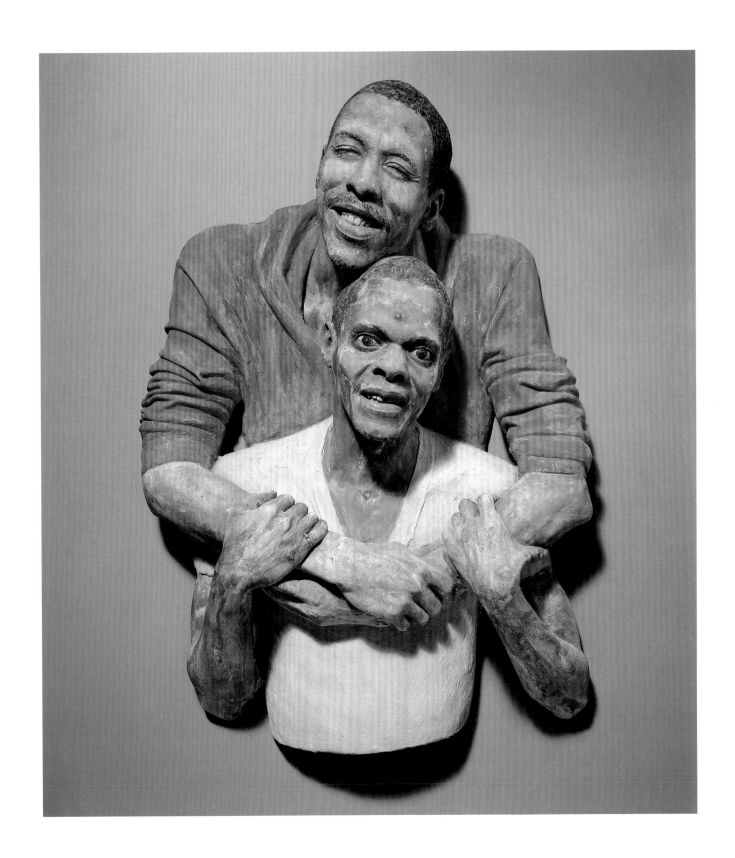

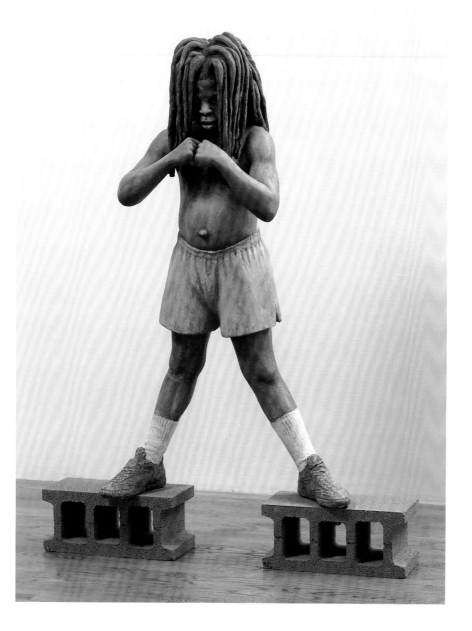

from having made plaster figurines in a factory owned by his uncle, Raul Arce. Ahearn was raised as a Catholic, and sensed a kinship between the plaster saints and madonnas manufactured by Arce's firm and his own sculptures. Between 1981 and 1985 Torres and Ahearn collaborated on four outdoor sculpture murals in the Bronx, funded by the Bronx Council of the Arts, the Department of Housing and Urban Development, and the National Endowment for the Arts. All of the murals feature multiple figures, cast in weather-resistant fiberglass and installed high on the sides of buildings. They show vignettes from work and school, domestic chores, and play. Ahearn is conscious of the relationship between these works and the murals and architectural reliefs made by progressive Mexican artists in the first half of this century.

For over a decade Ahearn has made art that addresses and stems from a collaboration with the residents of one of the poorest neighborhoods in New York City. By living in the South Bronx and depicting his neighbors, he works in a spirit of close interaction and exchange. Ahearn usually makes two sculptures of each sitter: one (designated the "uptown" copy) is given to the subject, and the other (the "downtown" copy) is destined for the art market. In 1986 the New York Department of Cultural Affairs gave Ahearn a commission for a mon-

< *Samson*, 1990-92. Oil on fiberglass. 62 x 46½ x 13 inches. Collection of Dr. Gerald and Phyllis Seltzer, Cleveland

I consider that these sculptures will probably be seen in an alien environment, in an environment that is extremely hostile to the characters I am representing. So I feel that it makes sense for me to project, with them in mind, as strong and as forceful a presentation of them as I can put together. . . . It is not that someone has to be hostile to confront hostility, but I think the characters have to come through with some kind of power or strength for them to survive in that kind of environment. — Ahearn in brochure for the exhibition "John Ahearn: Horizons," Nelson-Atkins Museum, Kansas City, 1990

umental public sculpture on a traffic triangle in front of the 44th Precinct Police Building in the South Bronx. He created painted bronze figures to stand on three separate plinths: a man kneeling with his pit bull, a girl on roller skates, and a man standing with a boom box and basketball. When the works were installed in September 1991, some residents complained, claiming that the project favored a white man's skewed perspective toward people of color, and that it projected harmful stereotypes. To put a hasty stop to the acrimony Ahearn had the sculptures taken down; they are now in the parking lot of the P.S. 1 Museum, Queens, New York. While Ahearn's sculptures were intended to celebrate racial equality, community pride, and ordinary heros, they became a focal point of community dissent.

Over the years, and despite the failure of the Bronx sculpture project in 1991, Ahearn's strategy has had obvious social and political ramifications in both SoHo and South Bronx. It fostered community pride and signaled the inclusive ideals of multiculturalism. Moreover, the South Bronx murals by Ahearn and Torres are model public art projects, for they affirm humanity in a community that constantly fights the despair of unemployment, isolation, crime, disease, and drugs. Rigoberto Torres is now a sculptor in his own right. Nonetheless, he and Ahearn recently reunited to create a sculpture workshop as part of the 42nd Street Art Project, a group show in Manhattan. ■

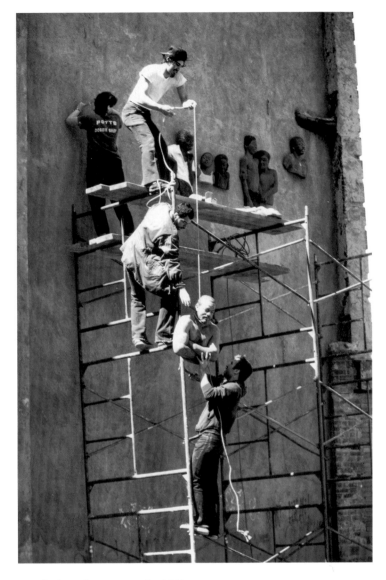

Installation of *We Are Family*, 1982

This is the first outdoor sculpture mural made by John Ahearn (bottom) and Rigoberto Torres (top). It is installed on a wall overlooking an empty building lot on Intervale Avenue at Fox Street, South Bronx.

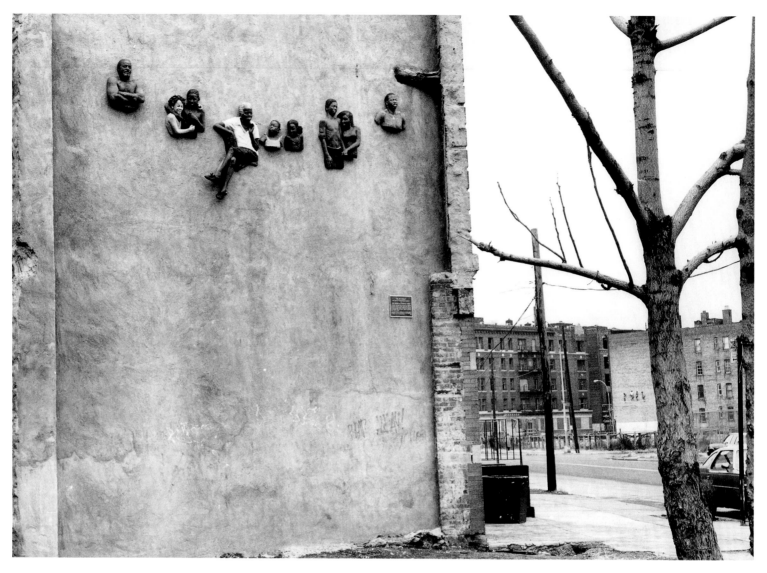

We Are Family, 1982. Permanent installation at 877 Intervale Avenue, South Bronx, New York

People sometimes try to say I'm doing this art for the benefit of the Bronx, but I'd like them to realize it's the other way around — that it's for the benefit of the art world, that the art world needs to broaden its horizons, that art suffers from its own myopia. That's one of its greatest weaknesses as a cultural force, and explains why it's so stagnant. . . . I would like my work to be political, but I don't believe in "politically correct" art. There's a Marxist point of view that generally was critical of me because I was producing expensive products for sale and bartering in people's images that weren't my own. But the critics making the accusations were speaking on behalf of the people of the Bronx without any real knowledge of the people or the place. Generally, people here think if you can make a stab at success you should go for it. — Ahearn in *New York Newsday*, March 6, 1991

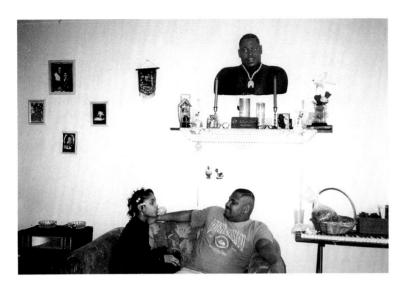

Cast of *Corey* (1984) with Corey Mann and his sister Veronica, 1993

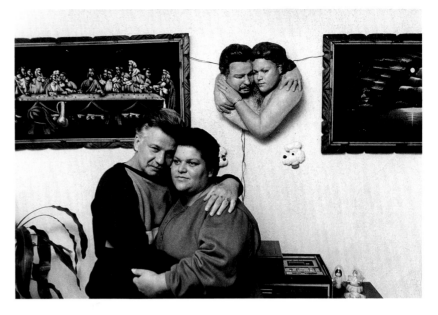

Cast of *Luis and Virginia Arroyo* (1980) with Luis and Virginia Arroyo, 1985

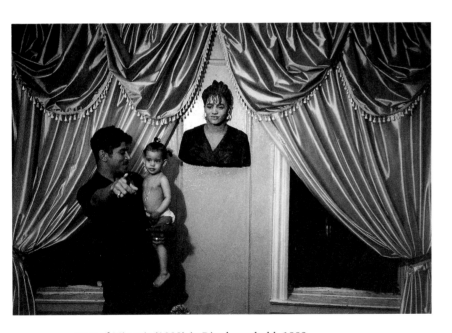

Cast of *Miosotis* (1993) in Dias household, 1993

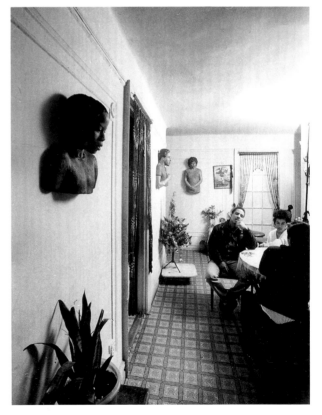

These photographs show Ahearn's neighbors at home, posing with their cast portraits. The artist is interested in documenting the ways his subjects incorporate his sculptures into their domestic lives.

Casts of (left to right) *Luis* (1984), *"June Bug"* (1984), and *Zunilda* (1985) with Steven "June Bug" Garcia (seated) and his sister Anna, 1985

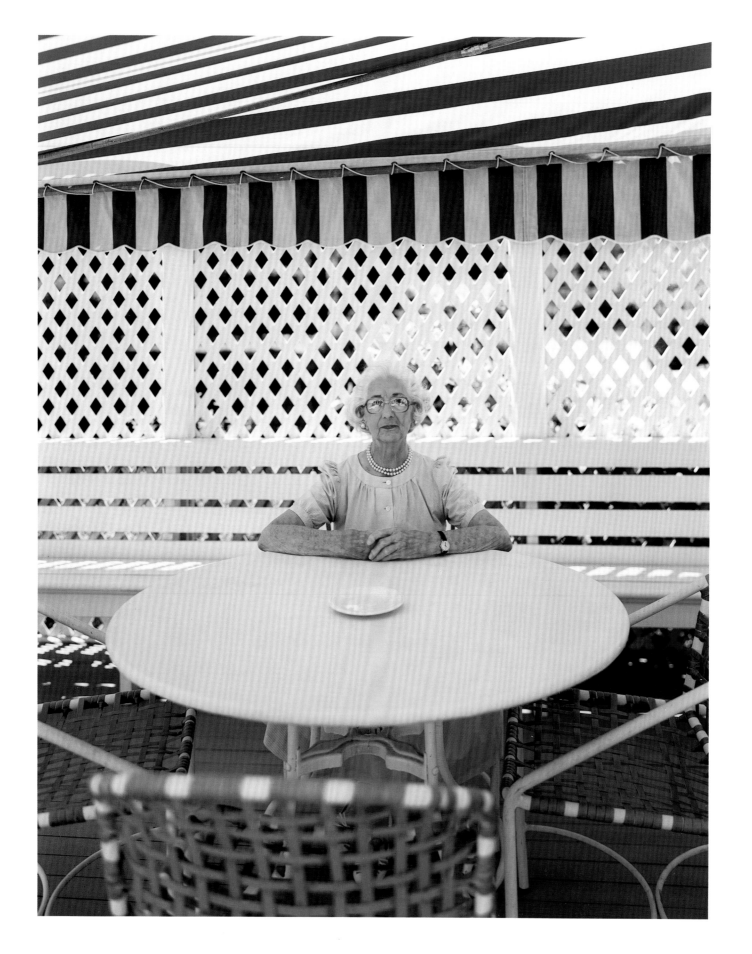

Tina Barney

1945	Born in New York City. Raised in Manhattan and on Long Island
1971	Joins the Junior Council of the Museum of Modern Art
1973	Moves to Sun Valley, Idaho
1976–79	Studies at the Sun Valley Center for Arts and Humanities
1979	Begins to photograph in color
1981	Switches from a 35mm camera to a view camera
Current	Lives in New York City and Watch Hill, Rhode Island

Tina Barney's large-scale photographs depict the lives and times of her family, her friends, and herself: white, upper-class, East-coast Americans. The settings glimpsed in her photographs are the richly decorated apartments, country homes, gardens, and beaches that Barney and her circle inhabit. The way of life represented in the work is one that the artist cherishes and wishes to protect.

Barney is a descendant of the Lehman family, a New York

< *Mrs. Barney*, 1991. Chromogenic color print (Ektacolor). 60 x 48 inches. Courtesy of Janet Borden, Inc., New York

The artist's mother-in-law seated in her patio. With this orderly and tightly controlled composition the artist makes her subject seem isolated and vulnerable; nonetheless, she projects an almost regal authority. It is not clear if Mrs. Barney enjoys this escape from the madding crowd, or if she is a prisoner of sorts.

Jewish banking dynasty, known to the art world for their endowment of a wing of the Metropolitan Museum of Art. Her mother was a fashion model and interior decorator; her father was an investment banker and an art collector. She had no formal art education and was first introduced to photography in the early 1970s, when she was asked to join the Junior Council of the Museum of Modern Art. Her first assignment was in the museum's photography department where she catalogued photographs for an exhibition. This experience inspired her to start collecting photographs and to visit commercial galleries. In 1973 she moved to Sun Valley, Idaho. She began taking photography classes at a local art center and learned to print her own film. Her early photographs were formal black and white studies of buildings and nature around Sun Valley area. However, Barney felt her most successful photographs from that period were those she made in the summer when she returned to her New England home and to the environment and lifestyle she knew best.

For twenty years Barney has concentrated almost exclusively on subject matter that is literally and figuratively "close to home." The photographs, which have brought her critical attention, involve a kind of personal narrative of the people and places she encounters in her life. She photographs certain subjects (or "characters" as she calls them) many times; viewers may recognize these individuals and follow them from picture to picture, as they might their favorite performer on a TV melodrama or soap opera. Barney invites her viewers into the space depicted; she has said "You can look. This isn't a secret world. You can go in there." One formal means of achieving this is to work in an almost life-size scale; her standard photograph is 4 x 5 feet. Barney locates her compositions in private realms that speak variously of good taste, tradition, shabby gentility, and occasionally, opulence. Her photographs display

furnishings and decor, clothing and personal effects, and people in great detail and in glossy vivid color. In this way her images and her style recall the advertising or magazine spreads that Ralph Lauren and Martha Stewart use to promote their home products and designs. The key difference between Barney's work and these commercialized images revolves around the notion of power: in Barney's pictures nothing is for sale, and the implication is that good taste and privilege are birthrights.

In their informality and intimacy, Barney's photographs resemble candid snapshots. Her characters seem unaware of the camera. It may be surprising to learn that Barney's pictures are actually the result of her careful arrangement, lighting, and color coordination (skills she credits to her mother, the interior decorator). To create a single picture, she often takes up to four hours and may use twenty sheets of film. She sometimes asks her sitters to repeat gestures or expressions over and over until she is satisfied, and occasionally she instructs them to change their clothes to make her picture "work." Barney uses a large-format camera because it produces 5 x 7-inch negatives with great clarity. Its major drawback is that it is cumbersome and difficult to use. Her camera is mounted on a tripod and she lights her photographs with multiple strobe lights and umbrellas. Friends and family have learned to expect Barney to lug this equipment along on weekends and holidays. Barney herself jokes about showing up at her sister's wedding with a light meter hanging around her neck.

In recent years Barney has moved her focus in closer, paying less attention to the setting, and more to her protagonists, their relationships, and their emotions. The artist acknowledges that it is difficult, both personally and technically, to reduce the distance between herself and her subjects. Many viewers see signs of trouble in paradise as they try to decipher the human situations captured by

Tim, Phil, and I, 1989. Chromogenic color print (Ektacolor). 48 x 60 inches. Courtesy of Janet Borden, Inc., New York

The artist posed with her sons for this family portrait. In her left hand she clutches the rubber bulb of the cable release that controls the camera shutter.

> *Thanksgiving*, 1992. Chromogenic color print (Ektacolor). 49¾ x 62½ inches. Museum of Fine Arts, Boston, Contemporary Curator's Fund, including funds provided by Barbara and Thomas Lee

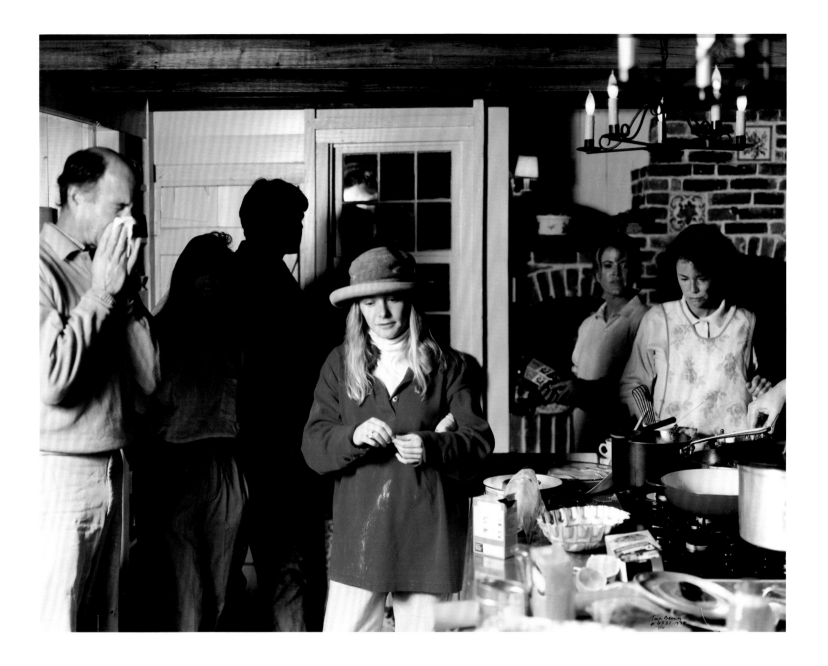

I'm documenting something that's important historically, that has never been done before, in photography at least, from the inside—a way of life that I don't think might ever happen again in America, because our priorities, or the ways people choose to spend their time, have changed so much. The time that it takes to live with quality—in a style of life that has quality—is disappearing. — Barney in *Friends and Relations: Photographs by Tina Barney* (Washington: Smithsonian Institution Press, 1991).

The Boys, 1990. Chromogenic color print (Ektacolor). 48 x 60 inches. Museum of Fine Arts, Boston, Contemporary Curator's Fund, including funds provided by Barbara and Thomas Lee

Barney. She, however, rejects ironic readings of her work: "A lot of critics say there's a twist to my work—because you look at [the photographs] and say, 'Oh this is great. Now there's got to be something wrong here. It's just too perfect'." Barney's denial notwithstanding, it is not hard to find discordant notes in her work—hints of boredom, isolation, and despondency. Often, her characters are shown in unflattering or distorted poses, and their facial expressions convey anxiety. These discordant notes may put the viewer on alert and allow a more critical reading of the subjects and interiors than the artist herself sanctions.

Currently Barney is working on a book project she began while in India on a Guggenheim Fellowship. The project will focus on the traditions, rituals, and family relations of three people—herself, a high-born Indian woman she met on her trip, and an American friend who was raised as a Mormon. ∎

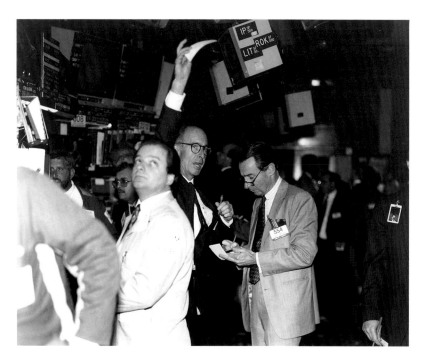

The Floor, 1992. Chromogenic color print (Ektacolor). 48 x 60 inches. Courtesy of Janet Borden, Inc., New York

< **Barney says she made this image of two old friends to show that the wealthy people whose lives she documents actually work. John O'Donnell (with arm raised) is a trader on the New York Stock Exchange; he also appears in a more casual setting in *Thanksgiving* on page 21. Discussing *The Floor*, the artist told the *Wall Street Journal* "This is the root of the sort of comfort the people I photograph live in. It's also the root of the problems they have."**

The American Flag, 1988. Chromogenic color print (Ektacolor). 48 x 60 inches. Courtesy of Janet Borden, Inc., New York

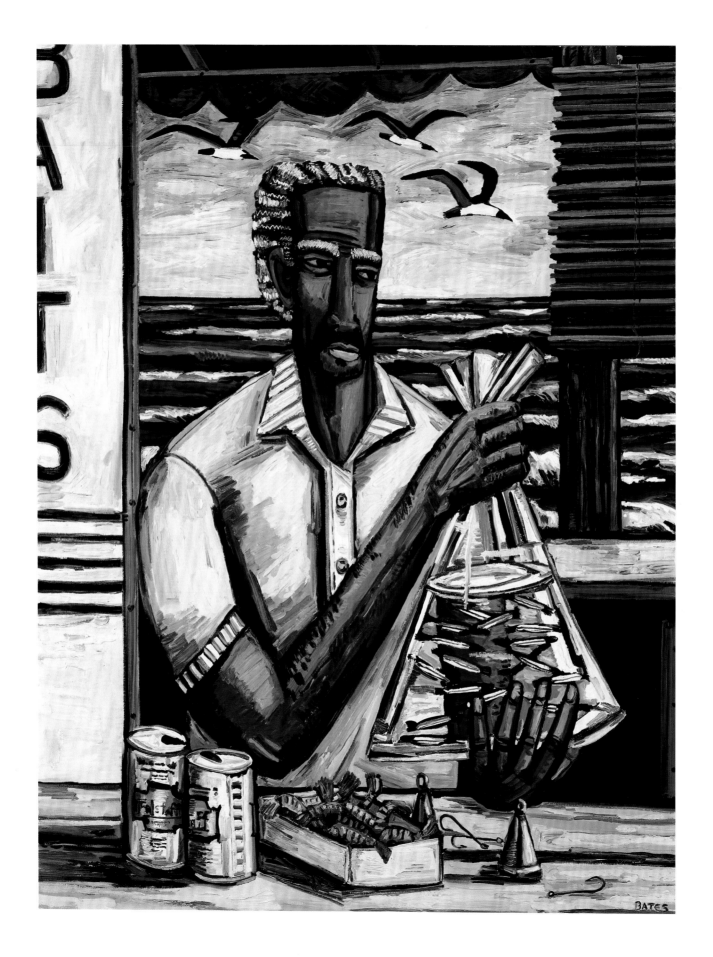

David Bates

1952	Born in Dallas, Texas
1975	Receives B.F.A. from Southern Methodist University, Dallas
1977	Attends Independent Study Program of the Whitney Museum of American Art
1978	Receives M.F.A. from Southern Methodist University, Dallas
1978-84	Teaches drawing, sculpture, and introductory art history at Eastfield College, Dallas
Current	Maintains residence and studio in a Dallas suburb

Bates is a painter whose subjects stem directly from a life spent in and around Texas. His early figurative works captured the "local scene" at rodeos, barbecue joints, and roadside stands; now he makes iconic images of backwoodsmen, hunters, and fishermen. He also paints amiable portraits of bird dogs, still lifes with catfish or luscious magnolias, and landscapes of woods, swamps, and the Gulf Coast. Since he depicts Southern imagery and works in a consciously crude or unfussy style he is often labeled an American regionalist, by Southerners and non-Southerners alike.

Bates was raised in Dallas, where his father was a traveling salesman for a menswear store. A flexible schedule allowed time for many hunting and fishing trips with his son. In school Bates favored art classes because dyslexia slowed down his

< *Baits*, 1990. Oil on canvas. 84 x 64 inches. Private collection

performance in other studies. At college he studied painting. He was very enthusiastic about the work of Red Grooms, a Tennessee painter and sculptor living in New York, and one of the few nationally known artists credited with a Southern voice. Bates sought to emulate Grooms's funky style and ebullient wit. When he visited Grooms in his Manhattan studio in 1975 he saw the celebrated installation piece *Ruckus Manhattan* in its final stages. Roger Winter, a drawing teacher in Dallas, was another influence on Bates's attraction to vernacular themes. He encouraged him to take bus trips and make quick pencil sketches of anything that captured his imagination. Bates remembers his surprise when the results looked like fifth-grade drawings: "I was so excited by making the visual image that I didn't worry about what it looked like exactly."

In 1977, Bates attended the Independent Study Program of the Whitney Museum of American Art in New York, eventually receiving credit from this study toward a master's degree from Southern Methodist University (SMU). In a sense he was an unlikely candidate for the Whitney Program, which emphasized critical theory and nontraditional art practices. Bates had learned of the program from Julian Schnabel, another young Texas-trained painter who studied there in 1973-74. In the year that Bates attended, the other students included Mike Glier, Jenny Holzer, Donald Newman (all artists), Becky Johnston (now a screenwriter), and Lisa Phillips (now a curator of contemporary art). Each week the students met with a different guest lecturer. Bates remembers in particular Philip Glass, Alex Katz, Brice Marden, Elizabeth Murray, Alice Neel, and Frank Stella. The program struck him as a "think tank or pressure cooker situation," and he now jokingly pretends that he was "the token dumb ass of the school." In fact Bates thrived in that environment, becoming a chameleon of sorts, eagerly trying out minimalist abstract painting, video, and performance art.

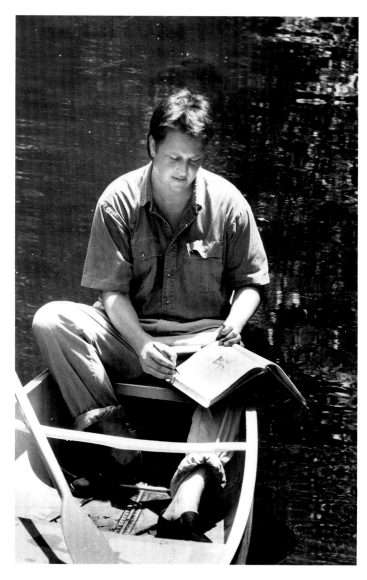

Bates sketching at Caddo Lake in East Texas, 1987

and to such self-taught painters as Horace Pippin (1888-1946). He adopted a "primitivist" aesthetic, and chose to disregard traditional modeling and atmospheric perspective.

Grassy Lake, painted in 1982, is an early example of the style and subject matter that Bates developed and continues to explore and refine. The composition is large, bold, and lively. The men and their boat are simplifed into massive, flat, angular forms. Certain oversized brushstrokes have a loose, playful quality, while other passages convey a delight in decorative patterns. The white man in the painting is Bates himself, and the black man is Ed Hawkins, a professional guide who works at a private hunting reserve in southern Arkansas. This seemingly innocent and sentimental image of rugged men engulfed in a "classic" wilderness is both a painted fiction and a sincere homage to a rural America that is virtually extinct: it survives mostly in national parks and private reservations.

In making paintings that are naturalistic and characterized by a bold formal simplicity, Bates positions himself between the high and low art traditions. On the one hand, he pays tribute to the works of humble American visionaries. On the other hand, he is conscious of the canonical artists who have favored similar formal qualities and bold visual mannerisms: for example, Bates values and emulates the work of Giotto for its spirit of rigorous simplicity. Bates can imagine himself on a long list of "high style" artists—Vincent van Gogh, Marsden Hartley, Pablo Picasso—who have exploited the example of "low" or popular art traditions. However, he presents himself first and foremost as an authentic Texas figure who celebrates vernacular expressions and the contributions of African-Americans to so-called "folk" traditions.

The year 1983 was a turning point for Bates. He was one of thirty painters from ten western states represented in the Cor-

Following his whirlwind year in Manhattan, Bates returned to Dallas, where he found little support for his experimentalism. For several months he attended lectures on art history at SMU, and entered a transitional period of self examination. Eventually, he decided to accept his inclination to make figurative paintings with bold, quasi-abstract, simplified forms. For inspiration he turned to anonymous folk, naive, or visionary artists

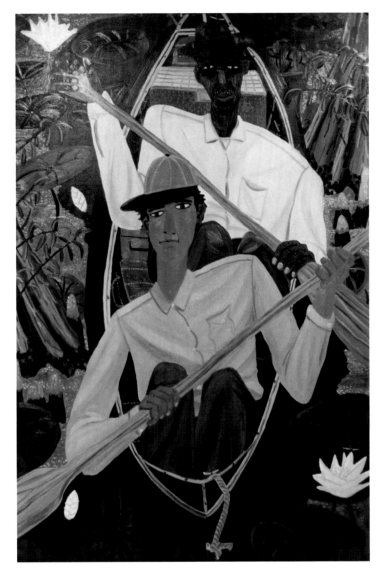

Grassy Lake, 1982. Oil on canvas. 90 x 72 inches. New Orleans Museum of Art. P.R. Norman Purchase Fund and Gift of Mr. and Mrs. Claude C. Albritton III

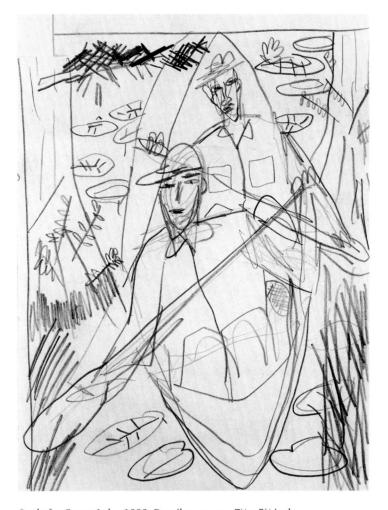

Study for Grassy Lake, 1982. Pencil on paper. 7¼ x 5⅝ inches

[Around 1979] I finally started looking at folk art again, and the folk art was exactly opposite to everything I had been taught in New York. It was non-pretentious, totally direct, done by people who are like religious fanatics, done by old, great characters who have maximum personal integrity, [and it was art] that seemed to be about rural subject matter a lot of the time. It was a way of abstraction that was as important to me as Picasso's abstraction. Anyway, about my paintings, everybody just said, "Oh, it looks like folk painting. You're not a folk artist." I constantly get that from everyone, which is good. — Bates in *Shift* magazine, 1988

coran Biennial in Washington, D.C. His work was included in the large group exhibition, "Southern Fictions," at the Contemporary Arts Museum, Houston, and he had his first solo exhibition in New York at the Charles Cowles Gallery. Bates benefitted from the renewed interest in image-based painting that had built steadily in the 1970s. He came to artistic maturity during the heady international revival of easel painting, which dealers, critics, and curators promoted and marketed in the early 1980s under the catch-all moniker, "Neo-Expressionism." It was logical at the time to apply this label to Bates's

Kingfisher, 1985. Oil on canvas. 96 x 78 inches. Collection of Laila and Thurston Twigg-Smith

A Warm Day in a Cool Month, 1987. Oil on canvas. 60 x 48 inches. Stuart Handler Family Collection, Evanston, Illinois

paintings, since they treated narrative subjects in a knowing, eclectic style—a sophisticated mixture of the modernist, expressionist, "naive," and folk-based visual languages. Bates's association with the international "revival" of painting obscured and oversimplified the regional and personal characteristics of his work. Bates is still developing and revising his original themes, even though Neo-Expressionism has been out of fashion's spotlight for several years. ■

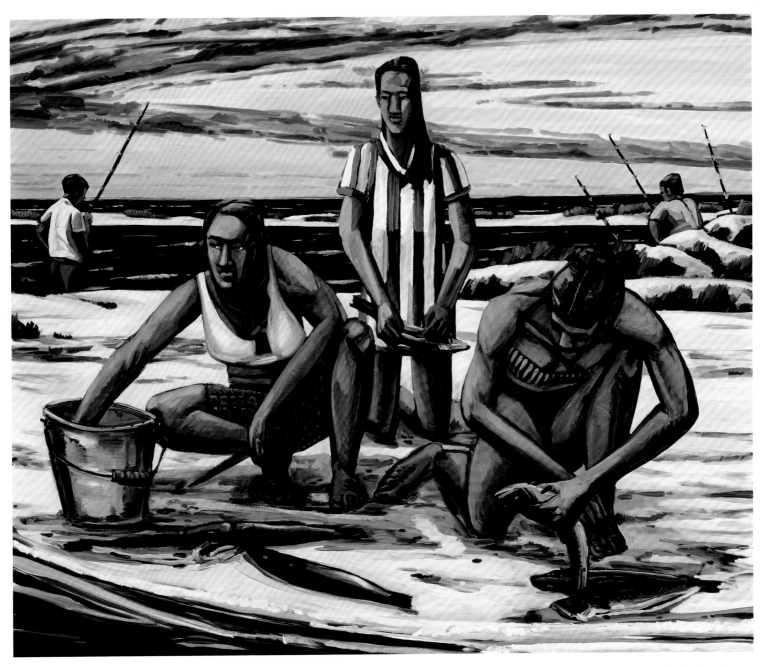

Matagorda Bay, 1989. Oil on canvas. 60 x 72 inches. Collection of Sondra Gilman and Celso Gonzalez-Falla

Matagorda Bay is midway between Corpus Christi and Galveston, Texas. The artist observed these Mexican-American women while on a fishing trip.

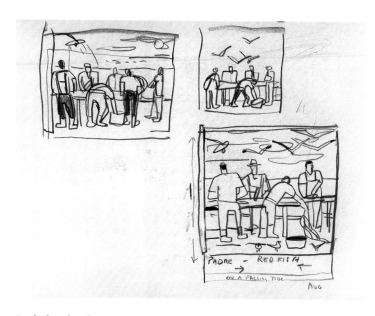

Study for The Cleaning Table, 1990. Pencil on paper. 8½ x 11 inches. Collection of the artist

In the sketches above, Bates depicts scenes at Rollover Pass, a man-made channel that allows fish to pass between the bay and the gulf. The men are gathered at a public table cleaning the day's catch.

Study for The Cleaning Table, 1990. Ink on paper. 9⅛ x 8¼ inches. Collection of the artist

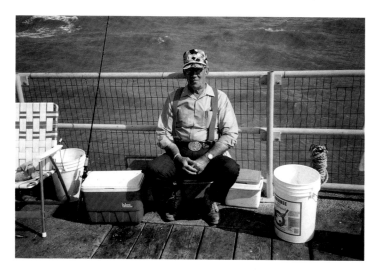

Snapshot of a fisherman, 1993

Bates took these photographs for this publication to document the fishermen in Galveston.

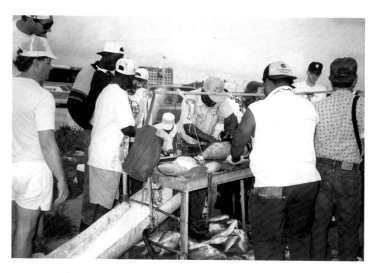

Snapshot of a cleaning table, 1993

> *The Cleaning Table*, 1990. Oil on canvas. 84 x 64 inches. The Barrett Collection, Dallas, Texas

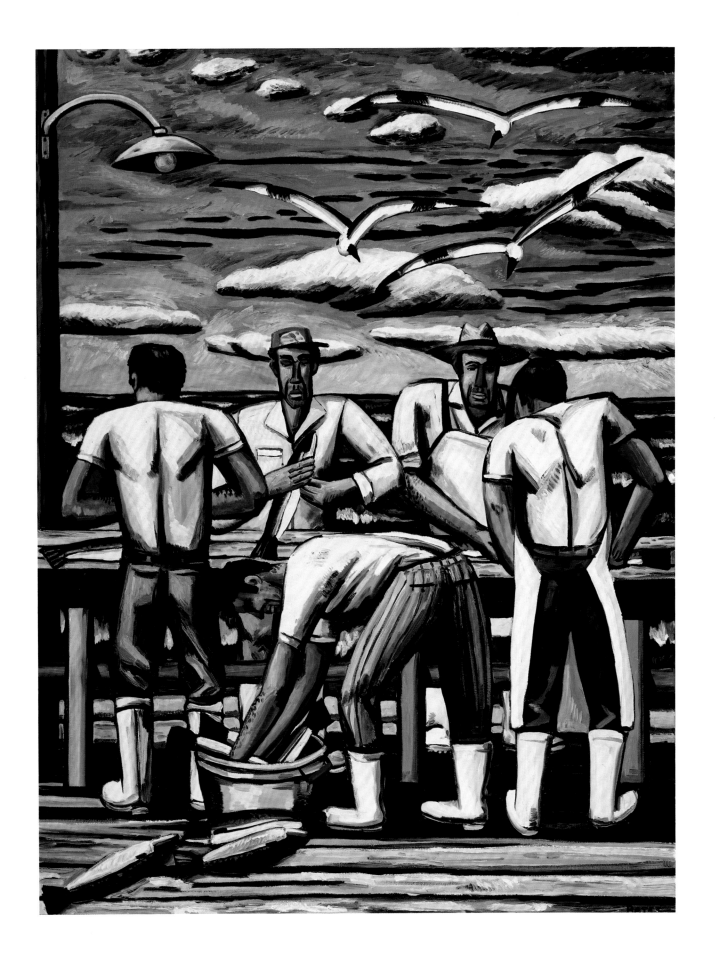

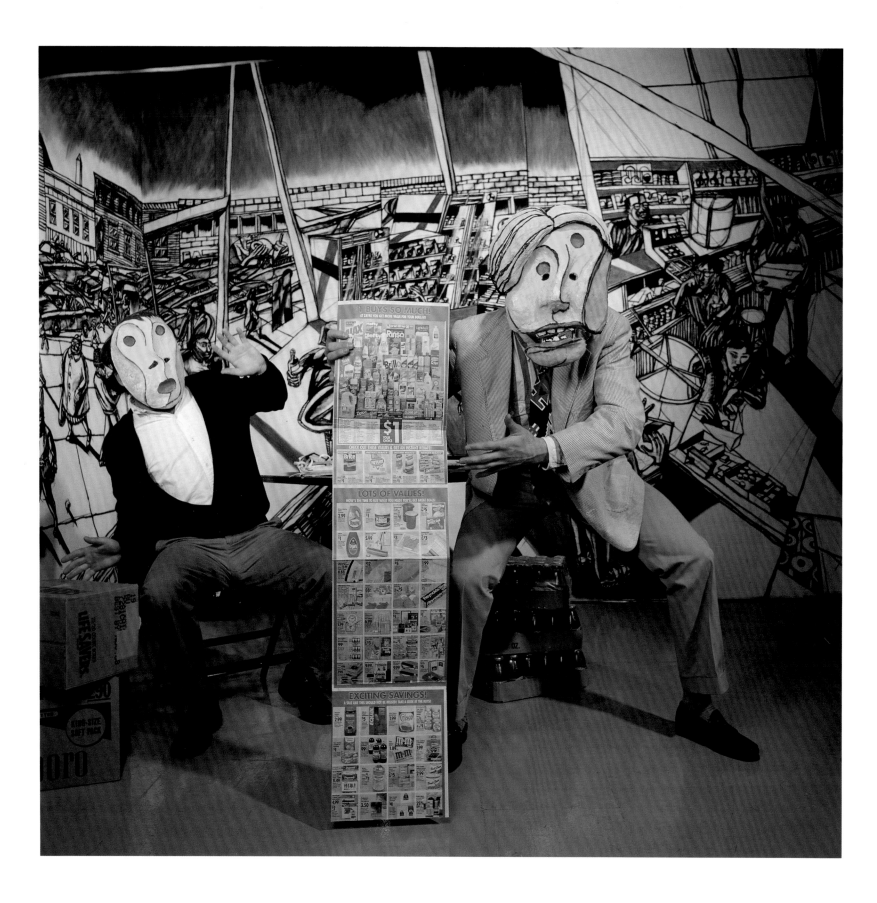

Y. David Chung

1959 Born in Bonn, Germany, to South Korean parents

1976-80 Studies art and literature at the University of
Virginia

1981-84 Lives in New York; works for a year as a street
portraitist in Central Park, then takes a job as a
graphic artist and animator for documentary films

1985 Moves to Washington, D.C.

1987 Becomes a U.S. citizen

1988 Receives B.F.A. from the Corcoran School of Art,
Washington, D.C.

Current Maintains a studio in Washington, D.C., and
residence in McLean, Virginia

Chung makes prints, drawings, watercolors, and installation
projects. His signature works are very large charcoal drawings
that reflect on daily life in racially mixed urban settings. He
often collaborates with other artists, writers, and musicians to
create multimedia performance pieces.

< "The Salesman." Scene from *Seoul House (Korean Outpost)*, by
Y. David Chung, Pooh Johnston, and Charles Tobermann. Washington
Project for the Arts. March 1988. Mr. Kim played by Jim Turner. The
Salesman played by Tom Wall.

**Most of the performers in Chung's rap opera *Seoul House*
wore dramatic, expressive masks in the Asian tradition.
Here, a white salesman browbeats the Korean-American
shop owner for not stocking his shelves to maximum
capacity.**

Chung had an itinerant childhood. His father was the Korean
naval attaché to Washington in the 1950s. Chung was born in
Germany and grew up in several countries, with many interim
periods in Seoul. He went to high schools in Tunisia, New
York, and Virginia. After attending college, he worked in New
York making drawings for animated science documentary
films. In this period, his parents retired from diplomatic ser-
vice and moved to Washington, D.C., where they ran more
than a dozen stores in different parts of the city—grocery
stores, newspaper stands in office lobbies, delis, and a Chinese
take-out. In 1985, Chung joined his parents in Washington,
becoming a student at the Corcoran School of Art, and work-
ing in the family stores.

Large figurative charcoal drawings were the focus of Chung's
first solo exhibition, held at Gallery K, Washington, in 1987.
These works used exaggerated poses, forced perspectives, and

Chung, 1992

Street Scene, 1987. Charcoal on paper. 80 x 55 inches. Private Collection

dramatic contrasts of light to evoke the psychological tensions, the ennui, and the latent violence of urban life. Their subjects ranged from stores, bars, and coffee shops to street scenes populated by anonymous strangers. A grand scale and an energetic narrative sensibility gave the drawings in this exhibition the collective impact of a mural. A critic for the *Washington Post* noted Chung's "fine eye for the demons of American excess." Another local writer characterized the work by mak-

ing an analogy with American twentieth-century social realist painting, from Robert Henri to Reginald Marsh. In addition to the influence of high art, Chung professes a love of comic book art, from mainstream to more idiosyncratic and subversive publications. The fast-paced visual narratives of this popular art form are echoed in Chung's predilection for juxtapositions of sweeping panoramas with graphic close-ups.

In 1988 Chung participated in Cut/Across, a group of cross-cultural art and theater projects presented by the Washington Project for the Arts (WPA). He made a group of drawings for a mural that showed the stockroom of a Korean grocery store and the street immediately outside. This installation also served as the setting for a performance piece called *Seoul House (Korean Outpost)*. Chung created this "rap opera" with composer/musicians Pooh Johnston and Charles Tobermann and performer Clearance Giddons (a soul and gospel singer whose stage name is Black Elvis). The soundtrack was a blend of rap, blues, soul, and electronic music. All but one of the actors wore masks and they mimed to the score using the mannerisms of Korean mask theater. The title plays on the words "Seoul" and "soul" to evoke the complexity of identity for Koreans living in the United States. Moreover, Chung suggests, the typical Korean store is set up and operated rather like a military outpost in hostile territory. The work also explores the painful dilemma of assimilation in the face of all-pervasive white culture. The shop owners strive tirelessly to succeed in the new country, but do so behind a barrier of cultural isolation. Their limited and impersonal exchanges with non-Koreans are seen in dialogues with a masked white salesman who pushes them to carry all the latest products, and a black delivery man who carries boxed goods to the stockroom. (Since its debut at WPA, *Seoul House* has been presented in several venues in California, Massachusetts, and New York.)

Chung's second multimedia installation was *Angulas—Street of Gold* (1990, Jamaica Arts Center, New York; later shown in Baltimore, Maryland; and Richmond, Virginia). This exhibition also served as a setting for performances of a one-act "opera" created in collaboration with musicians and writers. Chung made a mural drawing eight feet high and thirty-two feet long, which was augmented with collaged photographic images by Claudio Vazquez. The mural evoked the impressions of a recent immigrant from El Salavador who walks along a racially mixed modern city street. Washington's Mount Pleasant Street served as a model, but Chung considers the imagery to be typical of any large city in the United States. His streetscape is a far cry from the mythical golden pavements in centuries-old European visions of the "New World." The reality Chung presents is dominated by a sense of neglect and deterioration—run-down apartment buildings, sidewalks littered with trash, and a population of homeless people. The piece is named for *angulas*, a Spanish dish made from baby eels, that serves as a metaphor for the lively and confusing tangle of people who comprise the inner city today.

Chung's latest installation, *Turtle Boat Head*, was conceived during a residency at the College of New Rochelle, New York. It has been presented at the Whitney Museum of American Art at Philip Morris; the Wadsworth Atheneum, Hartford; and now at the Museum of Fine Arts, Boston. Chung lined a room with mural drawings and covered the large free-standing structure with more drawings. The structure represents an inner-city Korean grocery store; viewers may enter and watch a seven-minute video projection (made in collaboration with Matt Dibble). The video blends the past and present experiences of the man seen working behind the counter. A bullet-proof shield with a revolving service window separates him from a string of African-American customers, whom we can

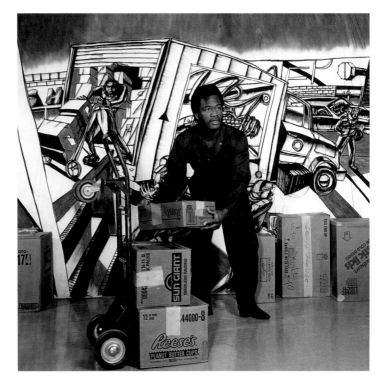

"The Delivery Man." Scene from *Seoul House (Korean Outpost)*, by Y. David Chung, Pooh Johnston, and Charles Tobermann. Washington Project for the Arts. March 1988. The Delivery Man played by Black Elvis.

A lot of different feelings come into play when someone comes here and tries to fit in; they don't know which way to go. They don't fit in with Afro-Americans; they don't fit in with whites; they don't know whether to stay in the Asian community or whether they are Americans. — Chung in *American Visions, The Magazine of Afro-American Culture*, 1988

Turtle Boat Head, 1992. Video stills

hear but not see on the videotape. In the moments between customers we see snatches of other memories and dreams that flash inside the Korean man's head: a traumatic youth during the Japanese occupation of Korea; emigration to the U.S.; the man's gracious suburban home and his church-going community of friends; television reports of the damage done to Korean-American businesses during the fiery rebellion in South Central Los Angeles in 1992. The mural in *Turtle Boat Head* presents a dizzying conjunction of images: for example, the burning of Empress Min at Kyong Bok Palace by Japanese soldiers in 1895; the resistance to the Japanese occupation (1905-1945); student unrest in modern Korea; the cycles of demolition and building that have created the commercialized cityscape of contemporary Seoul. The final section depicts iron-clad boats in the shape of giant turtles sailing into a modern harbor. In 1592 such ships, completely encased in their hard shells, repelled a Japanese invasion of Korea; they remain potent metaphors for Korean cultural identity and survival. In Seoul sculptures of turtles are placed all around the city as historic markers commemorating the deeds performed by Admiral Yi, the inventor of the turtle ships.

Chung is currently working on two new installations to be presented at the Queens Museum in the fall of 1993 and the Asia Society in the spring of 1994. He is also designing public murals for a new school building in Brooklyn, and for the Korean Youth Center in Los Angeles. ∎

> **At the center of the *Turtle Boat Head* installation is a large free-standing structure representing a Korean grocery store. The entrance is on the other side. The shop is covered with black and white drawings that show its clapboard and brick construction, and a slew of posters advertising movies, breakfast cereal, and athletic shoes.**

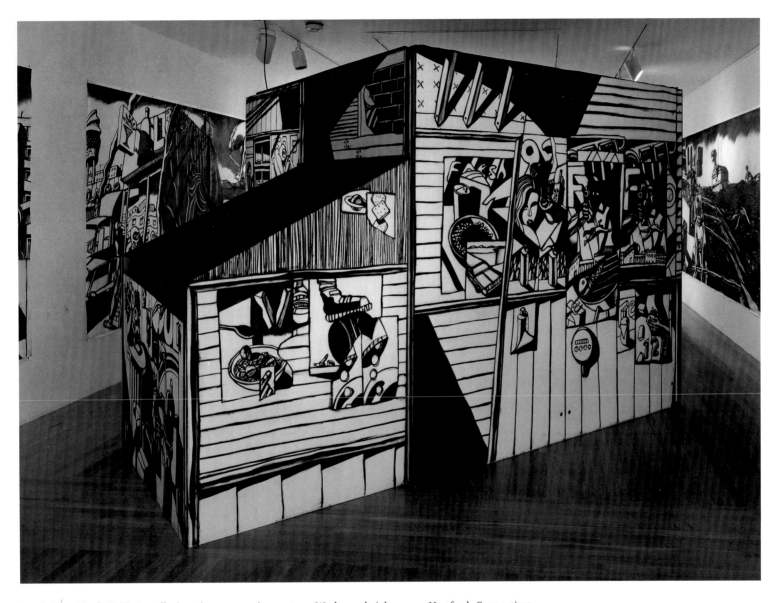

Turtle Boat Head, 1992. Installation view, convenience store. Wadsworth Atheneum, Hartford, Connecticut

To most Americans, Koreans are known primarily as convenience store owners and car manufacturers compounding the U.S. trade deficit. Koreans and other Asians are grouped together with little understanding of their ethnic, cultural, and historical differences. (Recently, in Brooklyn, New York, two Vietnamese men were attacked because they were thought to be Korean store owners) Little is known about Korea's past, but also how Korea's modern identity has been dramatically shaped by influences from the West. . . . There is a constant ebb and flow, as new ideas are embraced and old memories submerged. — Chung in his project description for *Turtle Boat Head*, 1992.

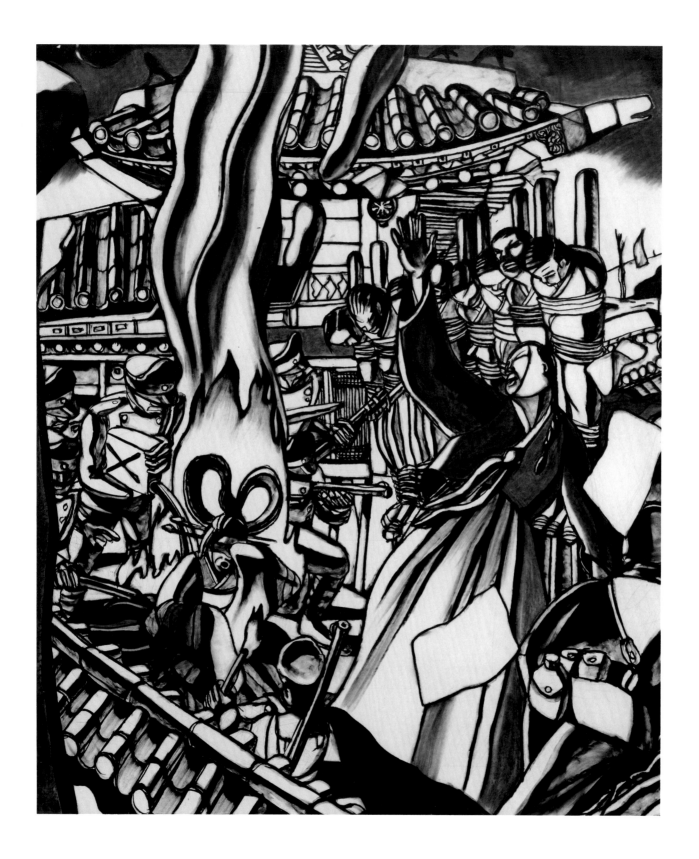

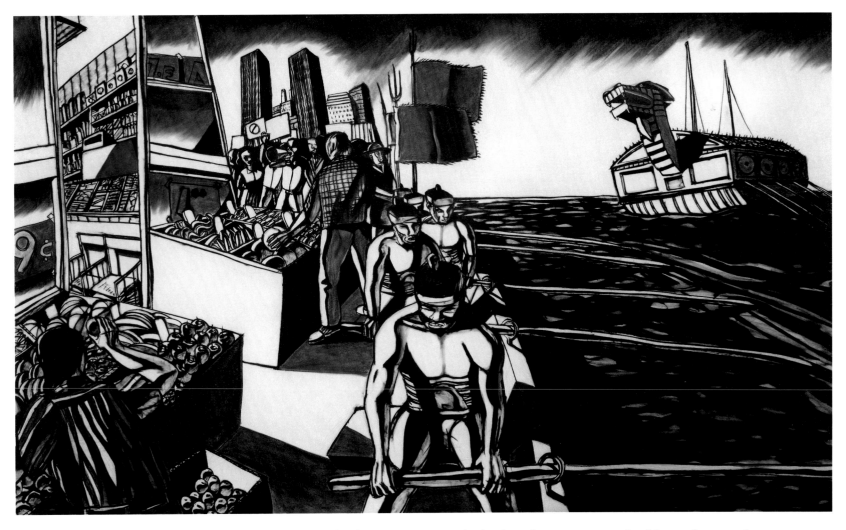

Turtle Boat Head, 1992. Detail of mural drawing. Wadsworth Atheneum, Hartford, Connecticut

On the horizon is a Korean turtle ship used to repel an invading Japanese armada in 1592. Surrealistically, Chung imagines a floating Korean grocery store as if to suggest that it, like the ancient ironclad boat, is an embodiment of cultural preservation in hostile times.

< *Turtle Boat Head*, 1992. Detail of mural drawing. Wadsworth Atheneum, Hartford, Connecticut

In 1895 Japanese soldiers stormed into the Royal Palace of Empress Min and burned her at the stake. To the right is a heroic depiction of Yu Kwan Sun (1903–1920), a student at Ewha University; behind her striding figure are the bodies of captive Resistance Movement fighters.

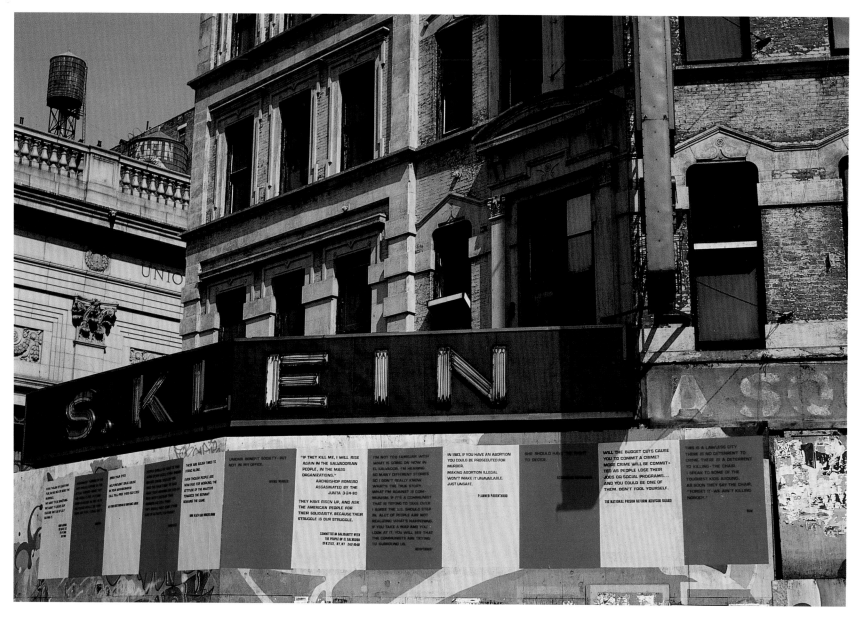

DA ZI BAOS, 1982. Union Square, New York City. Ink on paper.
8 x 60 feet

DA ZI BAOS, installed in Union Square on Manhattan's Lower East Side, was Group Material's first use of the Democracy Wall format. The artists illegally posted these brightly colored printed texts on a boarded-up department store scheduled for demolition.

Group Material

1979 Group Material is founded in New York. Its 12 original members include Julie Ault and Tim Rollins, later known for his role as the coordinator of the South Bronx-based art project Tim Rollins + K.O.S. (Kids of Survival)

1980-81 Opens and runs a storefront exhibition space in the East Village

1983 Organizes "Subculture," a month-long exhibition of display placards designed by 103 artists and artist groups presented on the IRT subway line

1987-89 Presents "Democracy" at the Dia Art Foundation, New York. The project consists of a series of four exhibitions, a book, and related programs including public town meetings and roundtable discussions with the artists and cultural and political activists

Current The Group consists of four members who live and work in New York: Doug Ashford, Julie Ault, Felix Gonzalez-Torres, and Karen Ramspacher

Group Material is an artists' collaborative based in New York City. Through thematic group exhibitions and projects, the collective addresses a wide range of topics from the AIDS crisis to the nature of democracy. Its members are committed to making art that is politically engaged and both community- and site-specific. Twelve artists and writers from diverse political and cultural backgrounds founded Group Material in 1979. The members were dissatisfied with the art world, its "star" system, and its commercial orientation. In an early manifesto

they defined themselves as an independent collective "committed to the creation, organization, and promotion of an art dedicated to social communication and political change." To that end, Group Material opened a storefront space in the East Village on 13th Street, where they presented eight thematic exhibitions that addressed the concerns of the people living in the neighborhood. They introduced themselves and their goals by distributing leaflets, which stated: "Group Material will be directly involved in the life of our neighborhood. Part of Group Material's working responsibility is to the immediate problems that shape the special character of this place: housing, education, sanitation, community organizing, and recreation."

A key project from this period was the 1980 exhibition, "The People's Choice" (later renamed "Arroz con Mango"). Members of the collective canvassed the largely Latino neighborhood along East 13th Street and invited residents to lend valued personal possessions to the exhibition. In a solicitation letter they asked for "things that might not usually find their

The Democracy Wall for Boston was created by:

Doug Ashford was born in Rabat, Morocco, in 1958; he has been a member of Group Material since 1982; he teaches at Cooper Union, New York, and at Vermont College.

Julie Ault was born in Boston, Massachusetts, in 1957; she was a founding member of Group Material; she lives in New York City.

Felix Gonzalez-Torres was born in Guaimaro, Cuba, in 1957; he joined Group Material in 1987; he lives in New York and teaches at New York University.

way into an art gallery: the things you personally find beautiful, the objects that have meaning for you, your family, and your friends." The resulting display included: religious artifacts, a Rembrandt poster, a Guatemalan knitted bag, family heirlooms and photographs, amateur paintings, clay bowls, home furnishings, and a collection of PEZ candy dispensers. In an article in *Art in America*, New Museum curator William Olander described the cumulative effect of the display this way: "Together this potpourri of local artifacts created a moving portrait of a small neighborhood within a community within a culture at large." After a year the collective decided to operate without a headquarters and abandoned its storefront gallery. Since then they have sought out exhibition opportunities with significant public exposure: on subways and buses, the sides of buildings, and in newspapers.

Group Material disregards traditional curatorial practice in favor of more inclusive, non-elitist approaches; their installations are thoughtful, stylish, and punchy, and often mix "high" and "low" cultural forms. For example, their installation *Amer-*

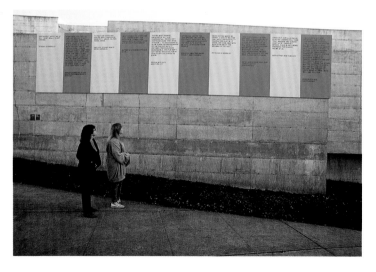

Democracy Wall, 1989. Berkeley University Art Museum. Ink on painted plywood. 8 x 60 feet

icana in the 1985 Whitney Biennial was a post-Pop extravaganza crammed with more than eighty objects. Forty-five artists were represented—from the acerbic realist Leon Golub to the apple-pie sentimentalist Norman Rockwell. Art was hung over or beside commercial designs, advertisements, and consumer products (including a Maytag washer and dryer). A continuous soundtrack played a medley of rock and roll, country and western, and elevator/supermarket Muzak. Six years later in the same space at the Whitney, Group Material exhibited *AIDS Timeline*, a multimedia installation addressing the first twelve years of the AIDS crisis. Unlike the earlier Whitney installation, this project was organized chronologically. A black line on the gallery wall marked the history of the epidemic from 1979, when American doctors first documented an increase in "immunologically unusual patients" (12 new cases, 11 deaths). Above and below the timeline was a selection of representations of the crisis and its larger social and political context. Included were works by numerous artists, community and activist responses, medical and government information, and material from mass media. In 1990, sections of the timeline were also published as inserts in art periodicals in observance of "Day Without Art," a day of national AIDS awareness organized by artists, museums, and galleries.

One form of public address that Group Material has developed and utilized over the years is the "Democracy Wall." This concept is inspired by the 200-yard brick wall near Tiananmen Square in Beijing, China, on which political activists post *da zi bao*, posters that express dissent, government opposition, and personal opinions. Group Material's Democracy Wall projects always contain a spectrum of viewpoints on a particular topic or theme. For example, in 1989 at the University Art Museum at Berkeley, the artists interviewed students, alumni, activists, and healthcare workers about their experience with and reactions to the AIDS crisis. Selected responses were typeset and

AIDS Timeline. From *1991 Biennial Exhibition*, Richard Armstrong, John G. Handardt, Richard Marshall, Lisa Phillips. New York: Whitney Museum of American Art and W.W. Norton & Company, 1991, p. 93.

exhibited on the side of the museum. The statements ranged from the blithe words of a current student ("AIDS doesn't affect me at all I don't really sleep around") to the testimony of an alumnus ("I'm a thirty-three–year–old man whose life and stamina resembles that of an octogenarian who is witnessing his contemporaries and friends die and whose own life is coming to an end").

For "In and Out of Place: Contemporary Art and the American Social Landscape," Group Material has organized a new Democracy Wall for the entrance of the Museum of Fine Arts, Boston. ■

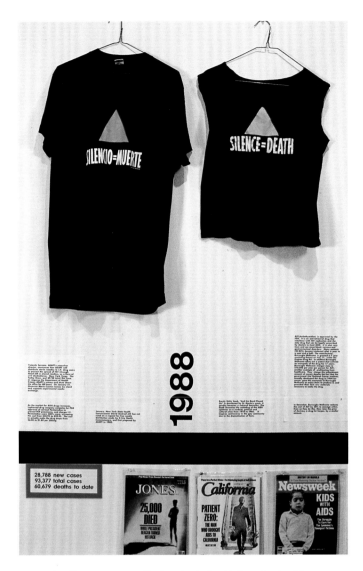

AIDS Timeline, 1989. Installation, Berkeley University Art Museum. Mixed-media. Dimensions variable

This section of the installation brings together artifacts and information relating to the AIDS crisis in the year 1988. The T-shirts are printed with SILENCE = DEATH, an urgent call to action, and a pink triangle, a symbol of gay and lesbian pride. AIDS activists, spearheaded by ACT UP, wore these T-shirts in street demonstrations to increase public awareness and to protest government inaction.

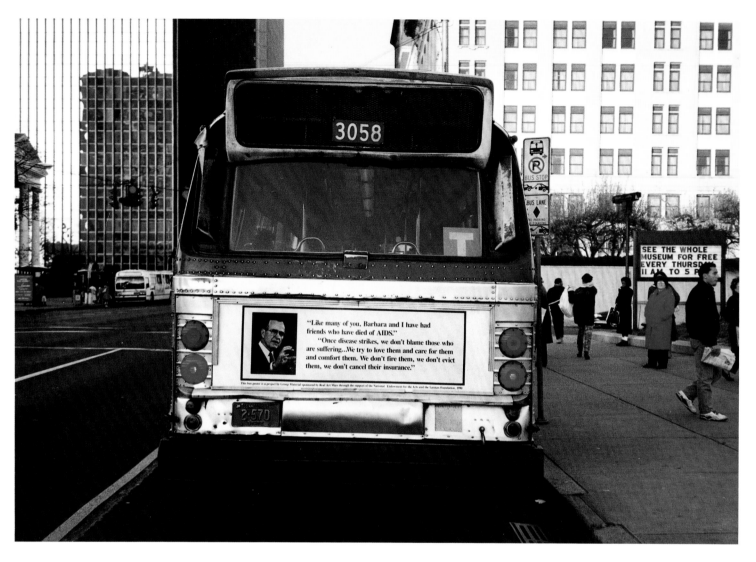

Group Material's public art project for Hartford, Connecticut, September–December 1990

A subject that no one in the art world wants to talk about is usually politics. Yet, because every social or cultural relationship is a political one, we regard an understanding of the link between politics and culture as essential. "Politics" cannot be restricted to those arenas stipulated as such by professional politicians. Indeed, it is fundamental to our methodology to question every aspect of our cultural situation from a political point of view, to ask, "What politics inform accepted understandings of art and culture? Whose interests are served by such cultural conventions? How is culture made, and for whom is it made? — Group Material in "On Democracy," from Democracy: A Project by Group Material, 1990*

"Like many of you, Barbara and I have had friends who have died of AIDS."

"Once disease strikes, we don't blame those who are suffering...We try to love them and care for them and comfort them. We don't fire them, we don't evict them, we don't cancel their insurance."

This bus poster is a project by Group Material sponsored by Real Art Ways through the support of the National Endowment for the Arts and the Lannan Foundation. 1990

Untitled, 1991. Bus placard. 1 of 50. 21⅛ x 70⁷⁄₁₆ inches. Museum of Fine Arts, Boston, Museum Purchase

In 1990 Group Material was invited to make a public project by Real Art Ways (a non-profit exhibition space in Hartford, Connecticut). Since that city is home to many of the nation's most powerful insurance companies, the collective decided to make a piece to address the problem of insurance and AIDS. They designed a poster to be displayed like a paid advertisement on the backs of municipal buses. The quotation is from the single reference to AIDS made by President Bush during his term in office.

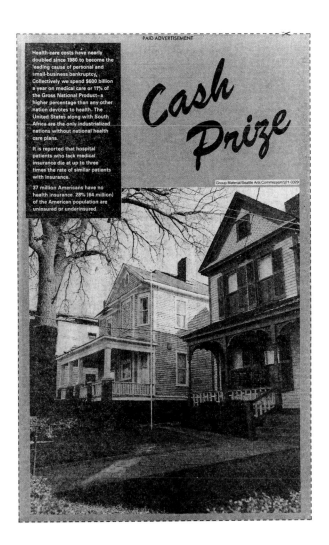

< *Cash Prize*, 1991. One of four paid advertisements in the *Seattle Post Intelligencer*, December 17-20, 1991. Sponsored by "In Public," The Seattle Arts Commission

What sometimes bugs me is that there are such incredible artifacts and that they're here in Boston. I wonder under what pretext they were taken out of their original countries.

Museum Visitor

. . .The museum holds its collections in trust for future generations. It assumes conservation as a primary responsibility which requires constant attention to providing a proper environment for works of art and artifacts. Committed to its vast holdings, the museum nonetheless recognizes the need to identify and explore new and neglected areas of art. It seeks to acquire art of the past and present which is visually significant and educationally meaningful. . .

Museum of Fine Arts, Boston
Mission Statement

This is the only major metropolitan museum in the country that doesn't get any city or state support. Initially these Brahmin types didn't want the government to be involved. This was to be their institution. So the museum went along happily for some time not charging for entrance and then the money began to run out. The initial impulse to reach out to a wider audience was an economic one. The building of the West Wing as a kind of a pleasure palace was to attract people — to up the gate. On a higher level there are many in the museum who feel that it is our ethical responsibility as professionals and as keepers of the art to reach out to our physical community and to a wider audience.

Museum Staff

I come from a small town in Pennsylvania and we didn't have any culture at all unless it had to do with coal mining.

Museum Visitor

It's close to Roxbury and yet aesthetically, culturally, and politically it's the farthest point away. The building looks like a rich white person's house. The museum is irrelevant to Roxbury because Roxbury is a community that has been denied anything that is Boston. I think the museum as a concept is obsolete. So I don't go. The exterior of the building is like a palate cleanser. And you shouldn't go to a museum with your palate cleansed. You should go with your art and culture on your mind and on your body.

Non-Visitor

People say if you're not reaching 80% of the population you're not valuable. I think the art is here, preserved, and on view, and this justifies the museum enough. There's a tendency to say the museum has to make itself relevant but people have to make art relevant in their lives and it's not only the museum's job to do that. What's probably most draining is the need to entertain and compete for the attention of people used to sitting and watching a half-hour TV show. There's something wrong with a culture when you have to work so hard to have a real experience.

Museum Staff

Proposal:

DEMOCRACY WALL for Boston
by GROUP MATERIAL

for "In And Out Of Place"

Group Material proposes to use The Museum of Fine
Arts as the site for a grouping of ten to twelve
large-scale signboards installed side-by-side on
the exterior of the museum's entrance facade. The
subject of the piece will be the role of MFA in
Boston and its functions as perceived by a vari-
ety of individuals with unique and differing
experiences of the institution.

Group Material's intention is to create a visual
representation of a dialogue using statements
from members of the public, and place it promi-
nently and publicly. Except in private conversa-
tion and focus-group situations, museum visitors
rarely have the opportunity to communicate their
motivations for going, expectations, describe
their experiences and responses to what they see,
or express their affirmations, criticisms and
desires for the institution.

Group Material will visit the museum and its
immediate area to conduct spontaneous interviews
along these lines of inquiry. A group of excerpts
will then be selected for reproduction and dis-
play. The selection does not represent Group
Material's opinions or artificially construct an
editorial but seeks to represent a range of
articulate responses and ideas.

The Democracy Wall form is a multi-voiced opinion
landscape that mirrors the way individual voices
echo, dispute, rub up against one another and
ultimately construct a picture of collective
experience. Group Material is committed to broad-
ening audiences and further encouraging interest,
engagement and participation in cultural institu-
tions. It is in this spirit that the project will
be formulated and conducted.

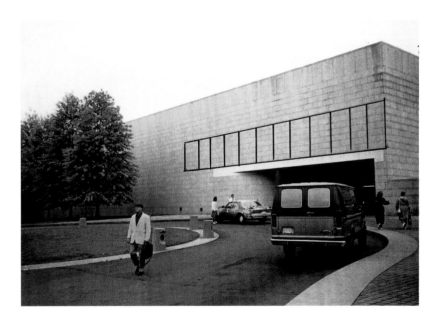

Proposal for *Democracy Wall*, 1993. Plan for a temporary outdoor instal-
lation at the Museum of Fine Arts, Boston. Submitted June 1993 to the
Museum of Fine Arts, Boston, by Group Material.

< Selected texts from *Democracy Wall* installation at the Museum of Fine
Arts, Boston, 1993

Krzysztof Wodiczko

1943 Born in Warsaw, Poland

1968 Graduates from the Akademie Sztuk Pieknych (Academy of Fine Arts) in Warsaw with a master's degree in industrial design

1977 Leaves Poland and moves to Canada

1984 Becomes Canadian citizen

1986 Receives his alien resident status, "green card," allowing him to live and work permanently in the United States

Current Divides his time between New York; Paris; and Cambridge, Massachusetts, where he is assistant professor of architecture at the Massachusetts Institute of Technology

Krzysztof Wodiczko creates artworks that function as symbolic and rhetorical public statements; his most celebrated works of the last decade are the "projections"—nighttime spectacles in which provocative images are projected onto prominent buildings or civic monuments. He grew up in Communist postwar Poland. After receiving a degree in industrial design from the Academy of Fine Arts in 1968, Wodiczko worked in a firm that produced such electrical products as radios and televisions. In his spare time he pursued his own art. Since overt political work was forbidden by government censors, Wodiczko developed a strategy of speaking metaphorically about public life. A key early work, *Vehicle* (1971–73) consisted of a long, seesaw-like platform on wheels. By walking back and forth on the platform the operator-activated gears and cables, setting the wheels in motion. The artist designed the apparatus to move

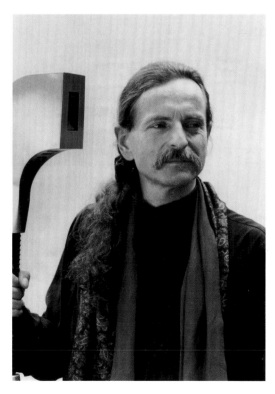

Wodiczko with a prototype for Alien Staff, his latest project, 1993.

< The Border Projection, at the San Diego Museum of Man, 1988. Outdoor slide projection. Organized by the La Jolla Museum of Contemporary Art

The artist made this projection on the façade of the San Diego Museum of Man. This institution in Balboa Park is housed in a Spanish Colonial style building created for the Panama-Pacific Exposition in 1915-16, which celebrated the opening of the Panama Canal. On either side of the entrance the artist projected a pair of hands brandishing a silver knife and fork; on the bell tower are hand-cuffed arms of a worker who proffers a bounty of fruit. These images allude to the Spanish Colonialists who exploited the land and its native people.

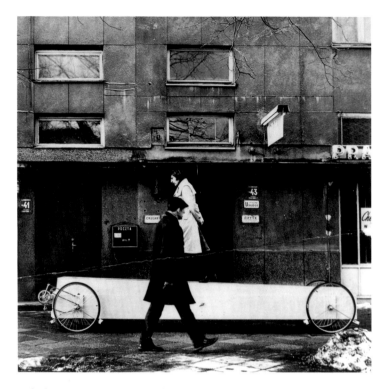

Vehicle, 1972. Warsaw, Poland

this country and abroad, although he does not consider any a "home."

Wodiczko first experimented with outdoor slide projections in Canada in 1980. Over the next decade the artist created nearly seventy different site-specific projections on the surfaces of buildings, monuments, and sculptures around the world. Typically, Wodiczko obtained permission for the projections, but on occasion he mounted guerrilla-style attacks— for example, in the projection of a swastika on the South African Embassy in London. Wodiczko made his projections in order to expose the ways in which civic buildings embody, legitimize, and perpetuate power. His projections revealed the coded messages communicated by these silent structures. One approach frequently employed by Wodiczko was to anthropomorphize a building by projecting hands, facial features, or a complete torso onto its form. Once equated with a human body, the projection makes explicit the secret motives embodied in the building: greed, dishonesty, corruption, and racism.

Wodiczko moved to New York City in 1983, where he witnessed first-hand the growing problem of urban homelessness. In the 1980s the number of people living on the street ex-

in one direction only as a metaphor for the lumbering bureaucracy of the Communist state, which alienated and disempowered its citizens. One important component of the work was its public presentation: Wodiczko decided that conventional exhibition spaces were confining and too removed from the public, therefore he presented his *Vehicle* by traveling on it through the city of Warsaw.

In 1977 he traveled to Canada to assume a visiting professorship at Nova Scotia College of Art and Design. While there, several of Wodiczko's associates at home were questioned by the Communist authorities. Realizing he too would be under government scrutiny if he returned to Poland, he remained abroad. In 1986 he received his "green card" granting him permission to live and work permanently in the United States. Presently, Wodiczko maintains several bases of operation in

> *The Homeless Projection*, The Soldiers and Sailors Civil War Memorial, Boston, 1986-87. Outdoor slide projection. Organized by First Night, Boston

In 1987, as part of Boston's New Year's celebration, First Night, Wodiczko chose the Soldiers' and Sailors' Civil War Memorial on the Boston Common as a site for this piece. For each of the four sides of the monument the artist produced a projection of homeless people flanked by plastic bags filled with their possessions. Huddling for warmth with their heads hung down they are both anonymous and pitiful. Onto the column he projects images from a local condominium construction site, making explicit the connection between homelessness and urban redevelopment.

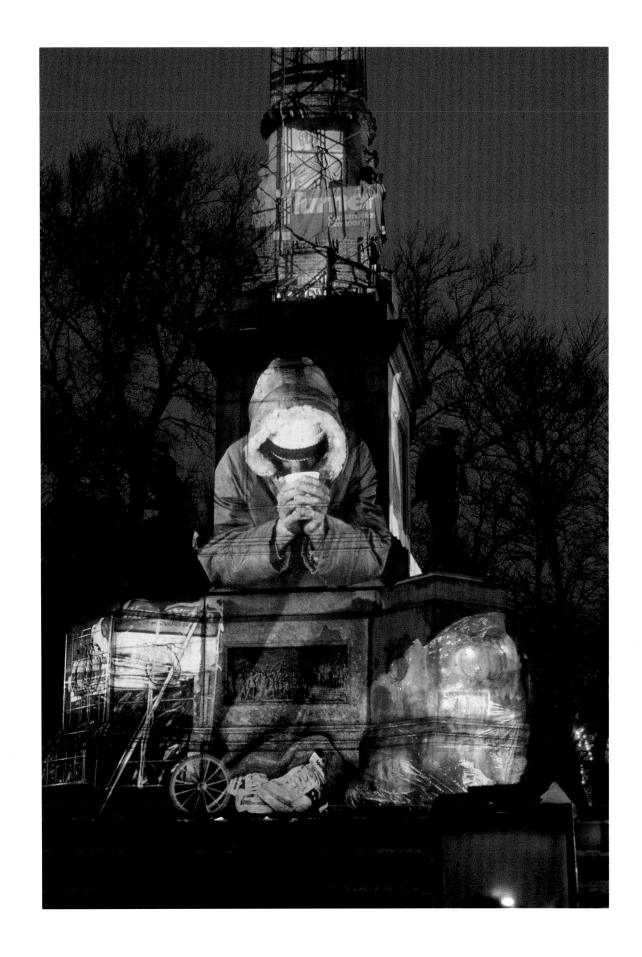

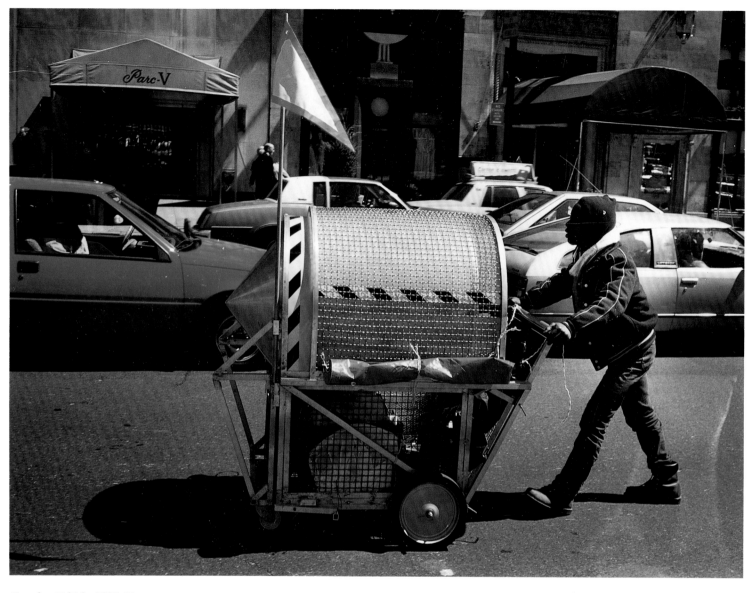

Homeless Vehicle, 1988-89

ploded, due to a combination of factors, including rampant real estate speculation and development, evictions caused by neighborhood gentrification, drastic cuts to government-funded housing projects, and the deinstitutionalization of the mentally ill. The police stepped up their efforts to "clean-up" public places, making the homeless (the artist prefers the term "evicts") refugees from the transformation of the city itself. According to Wodiczko, these individuals are like living monuments: "The surfaces of the homeless—over- or underdressed, unwashed, cracked from permanent outdoor exposure, and posing in their frozen 'classic' gestures—weather and resemble the official monuments of the city."

In 1987 Wodiczko began preliminary studies for the *Homeless Vehicle* to challenge the prevailing view of homelessness as an inevitable and insurmountable phenomenon. He designed four variants of the vehicle in collaboration with evicts who also served as test operators. The final design, which looked like a designer shopping cart, provided the evicts with rudimentary shelter, transportation, and storage space for the cans and bottles they collected to redeem for cash. It also included an alarm system to protect personal property and to warn of danger, a rear-view mirror, and a simple suspension system to assist the operator in moving through traffic. So far only a handful of vehicles has been made. Wodiczko designed them as symbolic objects that articulate the conditions of life on the street. They represent homelessness as a viable way of life requiring hard work, vigilance, and personal motivation. At trial presentations in New York City and Philadelphia, evict-operators moved purposefully through the city with their *Homeless Vehicles*, taking center stage and claiming their place as full citizens. For the "non-evicts" who witnessed the events, the vehicle became a focal point for deep-seated emotions about homelessness, especially the fear of becoming homeless.

Wodiczko's latest vehicle, *Poliscar* (1991), takes the ideas of *Homeless Vehicle* one step further. It originated as a commissioned proposal for the Cambridge, Massachusetts, Arts Council. *Poliscar* is a "mobile communications and living unit" that operates in three positions: walking, driving, and sleeping. At present there are two *Poliscar* prototypes. Each unit is equipped with a CB-radio, video recording equipment, TV monitor, loud-speaker, and surveillance camera enabling the operator to record, transmit, and receive information from other *Poliscar* operators. The vehicle is intended to be used by a segment of the homeless population with the skills and the motivation to organize other evicts, and to operate the "Homeless Communication Network," a mobile land-radio service. Like much of Wodickzo's work, *Poliscar* eschews simple solutions and asks more questions than it answers. Its awkward, even surreal exterior embodies this conundrum in that it expresses the profound sense of alienation experienced by the homeless while it also postulates a tenable way of life for those who lack a dwelling.

Wodickzo is currently working on *Alien Staff*, a ritual staff to be carried by immigrants. The staff is designed with connected compartments to store personal documents and belongings that tell the story of the person's past; its top contains a video unit. Wodickzo developed the concept for the project during a stay in Paris, where he was surprised to find that immigrant life closely parallels the situation of the American homeless. After crossing international borders, immigrants in France have to overcome cultural, ideological, and psychological boundaries. The staff is meant to provide its owner with a means to reduce physical and emotional alienation. ∎

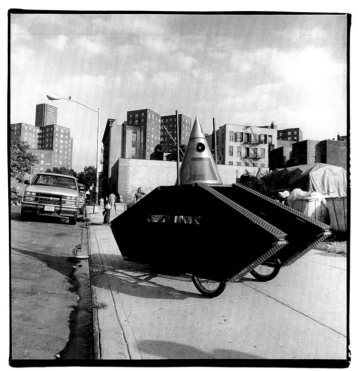

Poliscar (walking position)

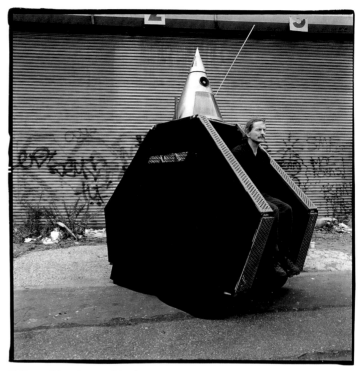

Poliscar (sleeping position)

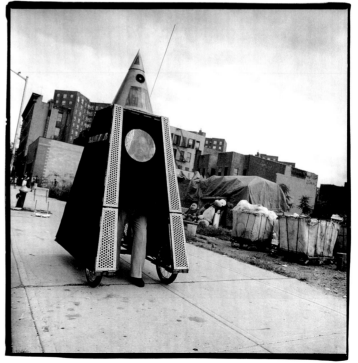

Poliscar (driving position)

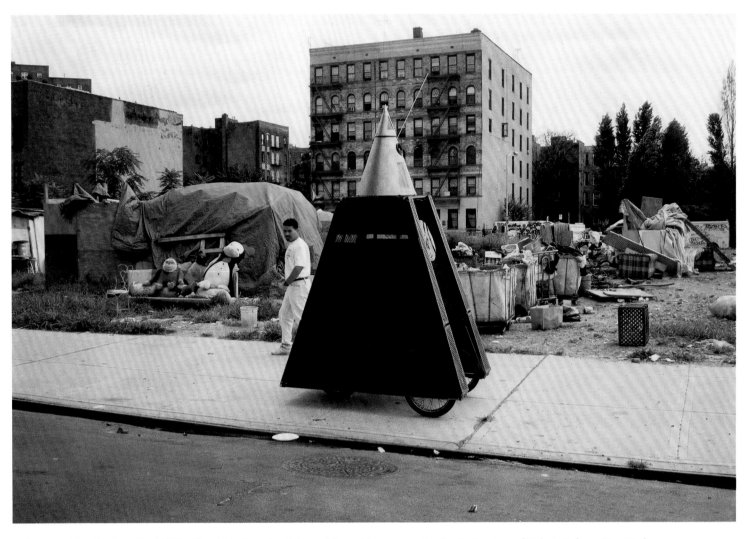

Poliscar, 1991. Mixed media. 122½ x 73 x 49 inches. (upright position with antennae in place). Courtesy of Galerie Lelong, New York

The homeless population is the true public of the city in that they literally live on the street, spending their days and nights moving through the city, working and resting in public parks and squares. The contradiction of their existence, however, is that while they are physically confined to public spaces they are politically excluded from public space constitutionally guaranteed as a space for communication. They have been expelled from society into public space but they are confined to living within it as silent, voiceless actors. They are in the world but at the same time they are outside of it, literally and metaphorically. The homeless are both externalized and infantilized and as externalities and infants they have neither a vote nor a voice. As long as the voiceless occupy public space, rendering them their voice is the only way to make it truly public. — Wodiczko in *Poliscar* exhibition catalogue (New York: Josh Baer Gallery, 1991)

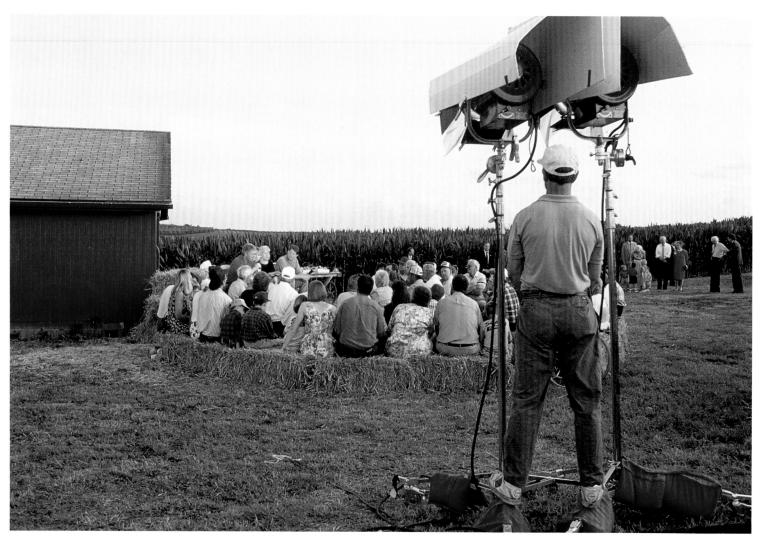

Nina Berman, *Clinton Campaign* (Utica, Ohio), July 1992

DEMOCRATIC VISTAS

I say we had best look our times and lands searchingly in the face, like a physician diagnosing some deep disease. Never was there, perhaps, more hollowness at heart than at present, and here in the United States. Genuine belief seems to have left us. The underlying principles of the States are not honestly believ'd in.

Out of the series of the preceding social and political universes, now arise these States. We see that while many were supposing things established and completed, really the grandest things always remain; and discover that the work of the New World is not ended, but only fairly begun.

Walt Whitman
Democratic Vistas, 1871

ONE

Any work of art constitutes a place of sorts: it is the site where viewers experience the summation of an artist's plans and activities. Whether it is an abstract image, a conceptual gesture, or a graphic depiction, a work of art also has an implicit point of view. I propose to characterize the different ways in which the artists in this exhibition explore the social landscape. This includes the nature of their involvement with their subjects as well as their use of a given medium to convey a point of view. The medium will favor certain kinds of facts or approaches to insight: for example, a photograph may or may not seem to be more factual or realistic than a painting; then again, a text-based conceptual work might prove to be a more effective means of provoking a strong personal response to a particular issue than either of these traditional means. How-

ever, I will begin by evoking the image-saturated culture that most Americans have in common. When we make personal decisions and form political opinions we rely heavily on the packaging we absorb from newspapers, magazines, films, and television. Our experiences at work, at home, and in the commercial world often mirror scenarios that we know from the media. There is great artfulness in the information, advertising, and entertainment industries, and since the early 1960s and the advent of Pop Art, increasing numbers of artists have addressed its visual language. More recently, such artists as Jenny Holzer, Jeff Koons, Barbara Kruger, Richard Prince, and Cindy Sherman have critically examined the cultural impact of the media on the social fabric. We share a growing need to interrogate images (from advertisements to art) for their overt and covert meanings—who is trying to say what to whom? Feminists and postmodern theorists have exposed the ideological workings of the dominant culture. As we grow used to presidential and governmental exaggeration and lying ("Read my lips") we are developing a healthy skepticism about everything marketed with a thinly veiled ideological agenda, from the latest "blockbuster" exhibition to a candidate running for office. This critical attitude is as necessary today as it was in the late 1860s when Walt Whitman was writing *Democratic Vistas*: we can confront difficult times by taking a searching look at ourselves as social beings, and one way to do it is through artists' depictions of the social landscape.

TWO

To explore the centrality of image making and mongering in our culture I would like to consider a picture taken by Nina

Berman (page 56), a photojournalist covering the 1992 Clinton-Gore campaign. The circumstances in which she made this work, and the context in which it was published, will serve as a parallel example to bear in mind later in this essay. Berman's photograph records an event in Utica, Ohio, on a farm selected by campaign scouts for a stop on the now-famous barnstorming bus trip from the Democratic National Convention in New York to St. Louis. Governor Bill Clinton, Senator Al Gore, and their wives joined local farmers for a meet-the-candidate discussion and picnic. The group sat on a circle of hay bales; close by were a big red barn, an old farm wagon laden with peaches, and a field of tall green corn. The farm setting was a savvy political choice by the Clinton team. Although most Americans do not live on farms, and have little experience of them, all know their symbolism. People may learn of the farm's contribution to Jeffersonian idealism in their introduction to American history; or they may experience its mythology when enjoying popular entertainments from *Oklahoma!* to "Hee Haw."

The discussion between the rural Ohioans and the casually dressed politicians was intimate, but not private: it was filmed by the campaign staff and observed by a convoy of press officials who had paid to follow the Clinton-Gore bus. Nina Berman made the staged nature of the event clear by photographing the event from the side. To find this revealing picture she had to leave the viewing stand that the campaign officials had set up to encourage a particular shot — a closely cropped head-on view of the politicians with the barn behind them. She fills her foreground with a technician attending to a pair of floodlights that were used to enhance the photogenic potential of the scene. Her picture also shows a few suited male security agents looking incongruous beside the corn field. Berman's view from the perimeter of the main event

Drawing by D. Reilly © 1993. The New Yorker Magazine, Inc.

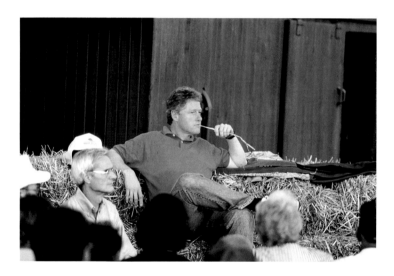

Nina Berman, *Clinton Campaign* (Utica, Ohio, July 1992)

draws attention to the Hollywood aspects of politicking, even in the generic American heartland.

Only days after the campaign stop at the farm the *New York Times* used a similar photograph by Berman to accompany an essay on the emergence of family values as a campaign issue.[1]

The fight over values entered the battle for the presidency when Vice President Quayle criticized the television sit-com "Murphy Brown" for having a single mother in the title role. (The fact that the Republicans were prepared to build their moral platform on the allegedly negative example of a television fiction demonstrates the power of images I am trying to describe.) The *Times* essayist characterized "family values" as a term that lacked definition and yet aroused the deepest convictions; it was a volatile and dangerous issue to debate. Since it was "not at all clear" what the candidates meant by the term, the *Times* asked: "To what extent are they using the notion to point up what they perceive as their opponents' weaknesses—Mr. Clinton's marital problems and appeals to gay and lesbian groups, Mr. Bush's air of detachment and poor record on the economy and racial issues? Or perhaps the family talk is simply fodder for sound bites."

Eleven months after the successful political stagecraft in Ohio a cartoon in the *New Yorker* returned to the scene for a bittersweet reflection on the fallout of the election hype (page 58). The publishing of Berman's photograph, the *New York Times* essay, and the cartoon all exposed the artificial aspects of the modern election process, and, more generally, the human propensity for wiling and scheming. The Clinton campaign had expected the Utica farm event to foster positive media coverage rather than the irony that these three commentaries evoked. In fact, Berman took photographs of the anticipated "official" variety at the farm event. One of them showed Governor Clinton quietly lost in thought, with a piece of hay in his mouth; he wears a red polo shirt and blue jeans. Given the extent to which presidential campaigns are now scripted and choreographed, we do not know if this was a cornball gesture to win votes, or a glimpse of an authentic informal moment. It is naive to expect that any image disseminated today in a political or corporate campaign is anything other than a sophisticated packaged product.

THREE

The adage "You can't judge a book by its cover" is a useful moral warning against ill-informed conclusions. However, when taken too literally it may promote a pious disdain for external evidence. In the case of people, the surface is a site of personal and sociological information: it is always too complex to be wholly comprehended, and hence endlessly interesting to artists, writers, and social scientists alike. An ability to read surfaces is essential in our industrialized culture. We are constantly targeted with "new improved" products; whether we like it or not, we project identities both through those things we consume and those we choose to ignore. When viewers confront the people in the art exhibited in "In and Out of Place," they will inevitably engage in this kind of reading of surfaces—typing individuals according to the codes and signals that they can see and read. People who strive to keep "art" and its issues wholly removed from "life" may not want to admit to this kind of looking. Recent scholarship suggests that the way a work of art is defined and understood depends upon what the viewer is looking for and chooses to see, in accordance with his or her ideological perspective.[2]

Oscar Wilde, an early connoisseur of the ironies of the modern condition, had this to say on the subject: "It is only shallow people who do not judge by appearances. The mystery of the world is the visible, not the invisible."[3] A century later, the visible realm swarms with endless types and forms of images, many of them circulated as commodities in the advertising, entertainment, education, and news/media industries. Now that we have the technology to alter, in a sense, to invent,

photographic information, the manipulation of "appearances" and the evolution of the criteria for "judging" them are likely to assume an ever more important role in the way business and politics are conducted.

Even as our technological civilization advances to the next scientific frontiers, the U.S. has been slow to accept and adjust itself to the premise of a multicultural society. Democratic freedom and equality in this country were originally claimed in the simplest terms. The Declaration of Independence characterized the "inalienable" birthrights of Americans as "life, liberty, and the pursuit of happiness." However, when George Washington was elected only a fraction of the population had the right to vote; more than three-quarters of the adults were excluded because of race, sex, or lack of capital. Subsequently, the people gained more freedoms through the democratic process of government: for example, in 1868 citizenship was given to freed slaves, and in 1920 American women won the right to vote. Present-day Americans are all members of a community based on ideals and freedoms, but the diversity of our racial and linguistic heritages is unprecedented. There are now more than 150 ethnic groups, and almost eight per cent of the population (19.7 million people) were born in other countries.[4] These facts are at odds with the images and values that are upheld by the predominantly "white" establishment. The media, politicians, and special interest groups monitor the ebb and flow of racial tensions on a daily basis. They can make it seem that the differences between us are more pronounced than the similarities.

The liberal hope for a shared American culture was once envisioned in a "melting pot" ideal—racial harmony and cultural assimilation via public education and common goals. An economic incentive for harmony and social conformity operated through the myth of the American Dream—the belief in every-one's potential to be a successful middle-class homeowner. The American Dream promised universal affluence, but essentially on the terms of the establishment's white, patriarchal, Christian, class-bound values. For decades it remained possible for the powerful to ignore the schism between this construct and the social realities of the United States. Those silently excluded were expected to be consoled by the privilege of living in the world's preeminent democracy. With the explosion of productivity after World War II, and the dawning of the information age, the disenfranchised proposed reforms in the name of equal rights and equal opportunities regardless of race, gender, religion, or sexual preference. With some major adjustments, it was still hoped that the American Dream might come true. Progress has been made on many fronts in the last three decades, and there is a new liberal agenda focused on multiculturalism, with its empowering metaphors of mosaics, rainbows, and the vast tribal diversity of ethnic, gendered, and sexual differences. Meanwhile, the prospects for an expanded sense of national well-being are being undermined by a new set of challenges. Having "won" the Cold War militaristic Americans have lost an enemy to fight in the name of freedom. At home there is an erosion of living standards, a drop in the general level of education, and an uneven distribution of medical care. Our government wages many domestic "wars"—on drugs, AIDS, poverty, crime, and terrorism. The nation's irresolution begins to feel like spiritual malaise, and is increasingly the topic of cultural and political analysis.

What follows is a discussion of the artists represented in the exhibition "In and Out of Place: Contemporary Art and the American Social Landscape." I do not pretend that their works can bring quick or major change to the national predicament sketched above; nonetheless, when art deals directly with the society in which it is produced it can provide insights, stir

emotions, and become a rallying point for dialogues. Interpreting art in a multicultural democracy has become as complicated and politicized as the times in which we live. There is a new awareness of the need to speak clearly and openly about the multiple meanings that artistic images can engender. It behooves us to discover what motivates artists to make their explorations, and to consider the many possible meanings a given work may hold for a diverse constituency of viewers.

FOUR

Traditional easel painting has an inherent capacity to approximate and fictionalize its subject, for the artist is free to edit and invent details when elaborating the empty canvas. It should not be surprising, then, that we talk of "the picture that is being painted" when we describe metaphorically the gist of an argument or cause. The figurative paintings of David Bates are examples of easel paintings whose visible information has been pared down from worldly reality to suit the artist's aesthetic vision. The art of Bates commands the highest prices of all the work in this exhibition; this is a clear reflection of the privilege traditionally accorded to paintings because they are still believed to be the most sophisticated means of image-making and the most revered vehicle for visual expression.

Bates paints people, mostly men, whom he has encountered on hunting and fishing trips away from his suburban home in Dallas. On these unluxurious retreats he seeks mental and physical renewal in nature. He takes with him a sketchbook for recording quick observations of striking people and places that he happens upon. If these encounters linger in his imagination they will be recalled in a painting weeks or months later in the studio. Bates reiterates the simplicity and directness of his pencil sketches when he paints a canvas; as a

David Bates. *Study for Baits*, 1990. Pencil on paper. 11 x 8 inches. Collection of the artist

result, his subjects often have the appearance of archetypes — the loner, the toiler, the regular guy. He seeks to capture in paint the "characters" that enliven the Southern or Texan vernacular. Class, race, and a stance of rough-edged independence are romantically embraced by Bates to invoke the human realities that are glossed over in the "white bread" version of the American Dream. He defines his subjects by their otherness.

When he transformed his original pencil sketch into the large

painting *Baits* (page 24) the artist altered several details. For example, he changed the vertical "ICE" sign on the left side of the drawing into one that reads "BAITS," creating a play on his own name. However, there was no change to the essence of the image, which remained an homage to a soulful African-American man working in a store by the ocean. The artist responded to the tenderness with which the older man cradled in his hand a plastic bag filled with water and tiny fishes. The subject's humanity and wisdom stand out against the mundane world of recreational fishing and beer drinking. Notations on the drawing indicate that the day was gray and the sea was dark; the words "Nash's son?" confirm that the location was Nash's beer joint and bait shop in Galveston, Texas. To some extent the editing and distilling that took place in the studio played down the unnamed individual in order to suggest a humanity that transcends race, class, and conventional manners. The fact that *Baits* presents its observations on a larger-than-life scale enhances its big-heartedness. It might be argued that racial guilt, an unusually involved topic in the South, is one of the elements that inspires Bates's respectful and compassionate representations of people of color. In addition, Bates is reiterating the cheery myth of the simplicity and honesty of "ordinary" people for the audience that can afford to buy his work.

Bates has a gift for handling thick, luscious paint. The way he slathers the medium reinforces the human vitality he mirrors in his canvases. As he constructs his painterly vision he steers the viewer's thoughts away from the harsher realities of his subjects' lives. He seeks a correspondence between the sincere affirmations of his subject matter and his ebullient painterly style. The finished works are often universal feel-good statements about the inner strength of plain people who experience American wilderness in the old-fashioned pioneer

manner. Ironically, Bates found the greatest artistic inspiration to paint such men and such inspiring natural settings on a private reservation owned and maintained by wealthy individuals who use it for hunting and recreation. More recently he has focused on the people he observes on the beaches and piers of the Gulf Coast.

Tina Barney is a documentary photographer whose work addresses the lives of upper-crust Manhattanites in the town-and-country milieu into which she herself was born. She has stated that her subject is "historically important," and that no photographer has ever attempted this "from the inside."[5] Barney also wants to impress the viewer with the art historical lineage of her documentary photographs. Some of her finely tuned compositions function as evidence of her awareness of such historical precedents as Dutch seventeenth-century genre scenes and domestic interiors painted by the Impressionists and Post-Impressionists. For example, she may portray the group dynamic at a family gathering, with details that highlight the emotional weather around one or two key figures. Other examples of Barney's work are framed more closely on the subjects and resemble oversized family snapshots, although these too are planned, color-coordinated and rehearsed, in deference to the "high art" imperative. Thus Barney's work has a compulsive ambiguity: her photographs are simultaneously reportorial documents and artful allegories, or, to put it another way, they are slices of life that are "good" pictures.

Barney believes that her style of life "will never again be experienced in America." She says this with a note of mourning, and then acknowledges "a feeling of guilt about the way I grew up and the way I live."[6] This ambivalence about herself and her class feeds the emotional confusion of her oeuvre. In many instances she creates elegiac records of the special plea-

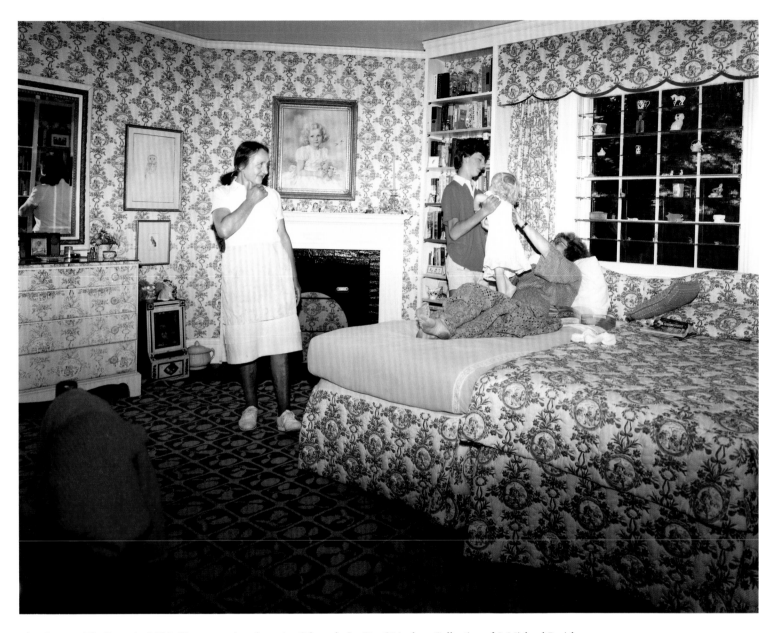

Tina Barney. *The Portrait*, 1984. Chromogenic color print (Ektacolor). 48 x 60 inches. Collection of J. Michael Parish

sures of a sequestered elite. Then again, in her need to give an insider's scoop on the supposed extinction of her set, she concocts some rather bitter pills. A critic recently argued that it was facile and flattering to say that Barney searches out the "empty moments" in the lives of her subjects.[7] He noted that her work voices grudging disappointment by recording unredeemed mundanity in a random accumulation of shrunken moments. Making things even more complicated, Barney has begun to insist that her primary concern is "how these people get along with each other."[8] Contradicting her documentary

impulses, she says "It's not the lifestyle and the interiors and those kinds of small things that matter."

In looking at David Bates's paintings there comes a moment when the abstract aesthetics of the surface supersede the specifics of the subject matter. In Barney's case the opposite is true: the wealth of "true" factual details that inspired the artist also sustain the viewer's inevitably voyeuristic interest. Some of these details and personal encounters have been staged by Barney, but many simply go with her turf. *The Portrait* (page 63) has a strong anecdotal capacity, and it is unusual in that a uniformed domestic servant is given a leading role in the picture. This middle-aged woman with swollen legs is shown gazing in seeming admiration at the blond infant that is being lifted from a bed. The photograph takes its title from an early-twentieth-century portrait hanging over the fireplace: some-what uncannily, it shows another blond child. This conjunction suggests a dynasty of such beauties, each remembered in a pretty portrait, and each attended by servants. *The Portrait* gives the viewer several narrative scenarios to think about: the stance that domestics must assume in the homes of their employers; napping as a bourgeois ritual; the accumulation of embellishments and prized possessions to signify heritage and class. The flash that Barney used for this picture brings out the oppressive aspect of the decor: its sharp glare heightens the nervous silhouette of the decorative motive that has been mercilessly repeated throughout the room. The social insights that Barney captures in this work confirm the outmoded cliché that the camera does not lie.

FIVE

John Ahearn is a portraitist, but he does not operate a conventional studio business, and his portraits oppose the notion of a flattering likeness made on commission. Ahearn once de-

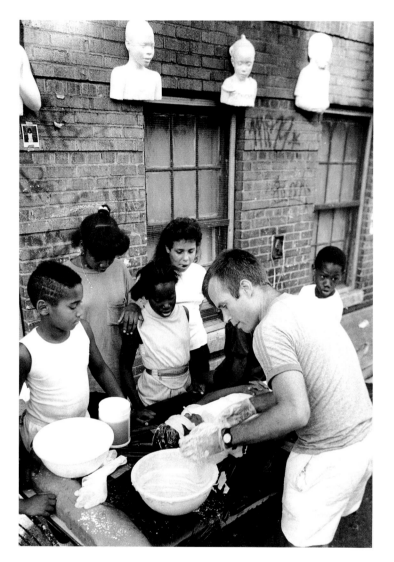

John Ahearn casting, 1988

scribed the basis of his work as a "friendship tie" with the subject. His act of portrayal involves a trade arrangement: in exchange for their participation, Ahearn's subjects have the opportunity to be cast a second time, for a free sculpture. His subjects are primarily working-class people of color from the South Bronx, where Ahearn has lived for over a decade. His project began on an optimistic note, for he believed he had discovered a means of portraying ordinary people through

mutual collaboration. Moreover, his depictions of people of color asserted a dignified presence in the largely white settings of commercial galleries and museums. Over the years, a few art critics have pointed to a flaw in this situation — Ahearn controls the representations of his subjects, and, in effect, assumes the role of a white person speaking for people of color.[9]

Ahearn's sculptures have an unusual duality: they are remarkable likenesses because of their technical excellence; but their overwhelming impact may function as racial stereotyping, depending on the circumstances in which they are exhibited and interpreted. There is an aspect of do-goodism to Ahearn's enterprise, and this probably encouraged a tendency to exoticize the people in his neighborhood. This inclination is apparent when we consider Ahearn's tremendous enthusiasm as his project took off. In 1982 he said "The Bronx is simpler. It's more fun here, more adventuresome. I am meeting some new people. It is the farthest reaches from the center of the art world. It gives me more psychic space. And these people, Hispanics and Blacks, are the vital people of New York City— they are swimming in energy."[10]

Ahearn has stayed committed to his original program and its contribution to community life. On a formal level, his skills in painting the casts have developed into a variety of styles, and the emotional range that he brings to his subjects is remarkable. His closeness to his community, and the ways in which he has tried to mirror its hopes and despairs, continue to produce inspiring works of art. His recent sculpture, *Raymond and Freddy* (page 13), is a deeply expressive portrayal of love between two brothers. Freddy, the figure with open eyes, is living with HIV infection, thus Ahearn's subject encompasses compassion and mortality as well as familial bonds and affections. Raymond's adult life has been difficult, and is now shad-

owed by a criminal record; but in the sincerest humanitarian spirit, Ahearn sees a good, kind, and sensitive man. Over the years, Ahearn has made individual casts of both brothers. This more complicated composition required three molds — one for each bust and another for the clasped hands. Ahearn colored the plaster with thin paint that dried to a delicate transparency, which seems to evoke the fragility and preciousness of life. The artist's deeply emotional record of tenderness between the Garcia brothers strikes many chords with other images of suffering and compassion that have been created throughout the history of Christian art. His work of art is an act of faith on behalf of the brothers and a testament to their humanity.

Y. David Chung grew up in a variety of countries because his parents were Korean diplomats. Until they emigrated to the U.S. in the 1980s, Seoul was the family's home base between diplomatic sojourns. Like John Ahearn, Chung deals directly with issues of racial identity, but his background and approach are entirely different. He speaks with the dual cultural voice of someone who is both Korean and American. Compared to Ahearn, who learned how to be a mediator between the Bronx's "black" streets and Manhattan's "white" museums and galleries, Chung represents the more complicated situation of a mixed cultural childhood that was later overlaid by immigration. Racial identity is not his only subject, but it is the lens through which he, as a non-white immigrant, filters his American experiences.

There is a parallel in Chung's work between the mixing that occurs in a multicultural society and the mixing that exists in the mind of any immigrant. Chung has a heightened awareness of then and now, there and here. He demonstrates this in the video component of his installation *Turtle Boat Head,* which evokes the shifting mental landscapes inside the head

Y. David Chung. *Turtle Boat Head*, 1992. Detail of mural drawing.
Wadsworth Atheneum, Hartford, Connecticut

Having emigrated to America (which in Korean translates to "Beautiful Country"), Chung knows first hand the strife and dilapidation that mar the dream vision. Being Asian, he also knows the anxiety and huddling that a language barrier and massive cultural difference can induce. On the other hand, he sees that recent Korean immigrants have generally been more upwardly mobile than African-Americans, whose history of oppression in this country is long and complex. The fact that Chung's own relatives have established a comfortable suburban base from which to run their city businesses seems to make him more conscious of those inner-city minorities whose lives are impoverished and embattled.

Chung's large "mural drawings" allow him to create richly detailed visual statements. Knowing his subject matter to be complicated, he has adapted a traditional form that gives him the space to be discursive. In his visually dense compositions he weaves together historical record, present-day realities, and the almost hallucinatory subjective impressions that an immigrant such as he might form when trying to hold together a fragmented past and a confusing present. The layering and mixing of visual information that occurs in Chung's art also serves as a metaphor for the complexity of any person's life. Korean-Americans are usually reduced to a few simple stereotypes in the mainstream media, but in Chung's work the viewer can glimpse the fullness of experience that is excluded in the debased language of sound bites and video clips.

SIX

Both Krzysztof Wodiczko and the artists' collective Group Material maintain a critical detachment in their relations with the commercialized art world. They seek to address the non-homogeneous general public, and are not willing to pretend that museum and gallery audiences have such diversity. Their

of a Korean-American. Such experiences are intense for immigrants to the United States, because they already have such strong fantasies of what the much-touted American way of life will be like. Had he stayed in Seoul, Chung would have known only the generic international version of Americanized urban environment—the concrete jungle of highrise developments, highways and overpasses, and spectacularly surreal billboards showing everything from toothpaste to paradise vacations. Chung would also have known many fictionalized portrayals of America from television; for example, the glamorous serial "Dallas," which was exported to ninety countries in the 1980s.

aim is to create bold objects that will spur viewers to ask questions and to consider direct action. Neither Wodiczko nor Group Material has a "signature style" that is easy to market. Knowing that commercial success is likely to bring with it the pressure not to speak plainly about injustice and inequity, they prefer to make projects for situations that are both urban and public—on the exteriors of buildings, in the streets, and through the mass media. Wodiczko does produce drawings and photographic documentations for circulation by his gallery, and Group Material has created a few prints and multiples; nonetheless, their work is much less likely to be encountered in the homes of wealthy collectors than Bates's delectable canvases, Barney's smart photographs, Ahearn's compassionate sculptures, and Chung's punchy prints and drawings.

Wodiczko's art is his means of fighting against the alienation that he sees directly expressed in the urban environment. In his recent projects he has exposed the circumstances that allow us to accept the homelessness of so many members of our society. He chooses to think of the homeless population as people whom others have evicted and displaced; in New York many of them would rather find a way to live on the street than accept the often unhealthy and dehumanizing conditions of shelters and dormitories. Wodiczko lays the blame with the local authorities and real-estate executives who in the 1980s pursued redevelopment and gentrification at any price. His way of bringing meaning and possible change to this situation is to confront and embarrass us with the consequences of reckless redevelopment. He finds the artistic means to present social facts that most bourgeois people hide from. With both humor and irony, he has designed two complicated and engaging objects—*Homeless Vehicle* and *Poliscar*. The former is a mobile living unit that all homeless people might use; the

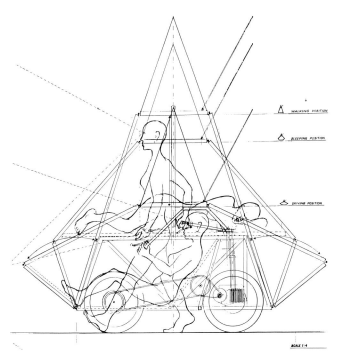

Krzysztof Wodiczko. Drawing for *Poliscar*, 1991. Graphite on vellum. 54½ x 34⅝ inches. Collection of The Linc Group, Chicago

Krzysztof Wodiczko. *Poliscar*, 1991

latter is a more sophisticated vehicle equipped to give community representatives the means to receive and transmit electronic information such as news reports from the streets. The artist has given both the techno-fetishistic aura of industrial design products, in hopes that they will seduce the "commodity-tuned eyes" of middle-class consumers. Both objects are working proposals for utilitarian vehicles that local authorities could develop; both prototypes have been tested on the streets and modified according to the advice of the homeless people the artist consulted. However, the artist emphasizes that the symbolism of these objects is as important to him as their ability to function in the city. He calls this the signifying function of the vehicles. Wodiczko wants gadget-loving American consumers to become curious about how his objects work. In doing this they will inevitably find themselves thinking about the daily lives, habits, and needs of the homeless. In this respect Wodiczko's work is a kind of lure that can seduce the viewer into critical thinking and a sharper socio-economic awareness. He sees his artmaking as an intellectual process — of opening up questions, of learning more about ourselves and our cities, of becoming more honest about what we are.

Group Material, like Wodiczko, produces art that subverts the expected roles of impressive commodity and sentimental decoration. However, it is a mistake to assume that the group's mission precludes the aesthetic: the visual power of their pieces is important in its own right and as a means for activism. This double agenda—to be both compelling and disconcerting—thwarts the tendency of art audiences to engage in passive and secluded consumption. When invited by the Seattle Arts Commission to create a public art project Group Material decided to make a work in the local newspaper. They created four different advertisement-like boxes of texts and images that ran on consecutive days in the *Seattle Post Intelli-*

gencer. This work of art was conceived as an experience to be had by any person who read the newspaper on those days. Each design featured a photograph accompanied by the words "Cash Prize," an attention-grabbing logo, and factual information set off as a block of text. One example juxtaposed statistics about the wealthiest and poorest people in America with a photograph of the cast of "The Brady Bunch," those impossibly innocent suburbanites. This happy-face escapism was televised from 1969 to 1973, during the last years of the Vietnam War in a period of radical social change. Group Material used the now-historic photograph of "The Brady Bunch" to remind us that mythic America is still very removed from the hard facts. Their juxtaposition of saccharine popular fantasy with easily ignored reality is the basis of their call for awareness, responsibility, and change.

For its contribution to "In and Out of Place: Contemporary Art and the American Social Landscape" Group Material has created a temporary artwork on the façade of the Museum of Fine Arts, Boston, directly over the entrance. It is a new example in their ongoing series of "Democracy Walls," large-scale text pieces that present a spectrum of public opinion gathered and edited by the artists. These works resist the reductivist tendency of opinion polls by being sites where opinions rub up against each other as they do in conversation. The subject of the new work is the Museum of Fine Arts itself. Group Material examines and assesses this cultural institution by working with a spectrum of visitors, staff, and neighbors. There are no images or names of people, only the words that struck the artists as considered and valid personal opinions. The Boston Democracy Wall project is also an opportunity for the Museum to hear from non-visitors: by opening itself up for this kind of dialogue, responsibly mediated by artists, the institution may win new support and respect. The fact that this artistic state-

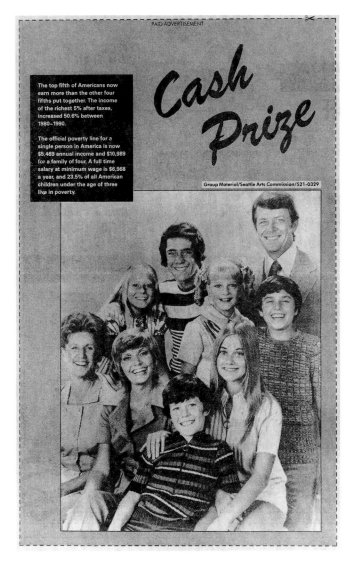

Group Material. *Cash Prize*, 1991. One of four paid advertisements in the *Seattle Post Intelligencer*, December 17-20, 1991. Sponsored by "In Public," The Seattle Arts Commission

tic statement is presented on the Museum's exterior helps to dissolve the notion of art museums as exclusive and unchanging fortresses for treasured objects. The Democracy Wall gives priority to ideas and to people's voices; and, although it is short-lived, it can be a beginning for a more extensive commu-

nity dialogue in the future. The other artists in this exhibition focus their works on particular communities, classes, and ethnic groups. Group Material abandons this specificity in favor of a more democratically rooted process.

SEVEN

In the last decade American contemporary art has been produced in an embattled climate. In 1989 right-wing politicians and Christian fundamentalists scared the National Endowment of the Arts and many of its beneficiaries into a panic of self-censorship. Flouting American constitutional freedoms, they incited public controversy in the name of moral and religious authority. One target was a retrospective exhibition of art by Robert Mapplethorpe (an internationally renowned, openly gay photographer), another was a provocatively titled work by photographer Andres Serrano, *Piss Christ*.[11] The NEA proceeded to ask its grant recipients to sign an "anti-obscenity" pledge, but widespread protest neutralized and reversed this measure. These episodes exposed the right wing's fear of art's freedom of spirit and its unique power to question realities, truths, and meanings by envisioning alternatives. Many influential critics, collectors, and curators are today dubious about art that embraces social and political concerns, especially when it strays from the traditions that are guidelines for assigning market "value" and aesthetic "quality." When art unequivocally flouts these conventions it runs the risk of being dismissed as prescriptive, hectoring, and didactic by those who stand staunchly by tradition. Artists are more likely to win mainstream approval if they deal with social issues on the more vague level of metaphor and abstraction. I hope that the broad and eclectic group of artists in this exhibition will make it less easy to type work according to a yes/no test on social and political issues. There are many ways for artists to

approach the pressing subjects explored here, and many ways for viewers to interpret them.

Our current national malaise in some respects echoes that of the period in which Walt Whitman wrote *Democratic Vistas*. In the aftermath of the Civil War, he and the country were physically and spiritually exhausted. Nonetheless, he gave honest voice to his outrage over corruption, while remaining deeply optimistic in his democratic idealism. His belief in humanity continues to be a source of hope. Democracy, he wrote, "is a great word, whose history, I suppose, remains unwritten, because that history has yet to be enacted."

TREVOR FAIRBROTHER

Beal Curator of Contemporary Art

NOTES

1. Andrew Rosenthal, "What's Meant and What's Mean in the 'Family Values' Battle," *New York Times*, July 26, 1992, section 4, p. 1. The words "Just Folks" were printed in one corner of Berman's photograph.

2. See *Art After Modernism: Rethinking Representation*, ed. Brian Wallis, The New Museum of Contemporary Art, New York, 1984. Also, David Freedberg, *The Power of Images: Studies in the History and Theory of Response*, (Chicago: University of Chicago Press, 1989).

3. Oscar Wilde, quoted in Susan Sontag, *Against Interpretation and Other Essays* (New York: Farrar, Straus, & Giroux, 1966), p. 3.

4. Statistics cited by John Lichfield in "Campaign '92: Dream of an Aged Child," *Independent* (London), November 1, 1992, p. 19.

5. Quoted in *Friends and Relations: Photographs by Tina Barney* (Washington: Smithsonian Institution Press, 1991), p. 6.

6. Quoted in Andy Grundberg, "Tina's World: In Search of the Honest Moment," *New York Times*, April 1, 1990, section H, p. 39.

7. David Rimanelli, "People Like Us: Tina Barney's Pictures," *Artforum* 31 (October, 1992), pp. 70-73.

8. Quoted in *Friends and Relations*, p. 12

9. Ten years ago, Robert Storr wrote, "Once lifted from their [urban underclass] setting and placed in the neutralized confines of a midtown gallery, what is truly human and distinctive about these images is all too easily transformed by the lust for exotic fetishes and the falsely homogeneous vision of Family-of-Man humanism into simple moral or folkloric artifacts. . . . If these portraits are to extend their effect beyond their initial impact, the artists must make it harder for their gallery audience to identify with and assimilate them. Somehow they must make what their subjects think and feel about our scrutiny as explicit as how they look when at ease in their own surroundings." ("John Ahearn and Rigoberto Torres at Brooke Alexander," *Art in America* 71 [November 1983], p. 227).

10. Quoted in Jeanne Siegel, "The New Reliefs," *Arts Magazine* 56 (April 1982), p. 143.

11. *Piss Christ* is a lyrical photographic depiction of a crucifix in a luminous, seemingly cosmic space. Without the title, the red-hued visionary image could function as a conventional icon of the doctrine of Christian redemption. Most alarming to conservatives and fundamentalists was the artist's admission that he had submerged the crucifix in urine literally and metaphorically locating the spiritual in the corporeal. For more information, see Richard Bolton, *Culture Wars, Documentation from the Recent Controversies in the Arts* (New York: New Press, 1992).

Y. David Chung. *Turtle Boat Head*, 1992. Video still

SITE-SPECIFIC: THE AMERICAN CITY

On April 29, 1992, fires burned in Los Angeles. News of the acquittal of four white police officers accused of beating black motorist Rodney King set off a violent protest. Outraged at the verdict, poor blacks, Latinos, and a few whites set fires, looted stores, and attacked passing motorists and pedestrians. The rampage began in the downtown area and in South Central Los Angeles, but it soon spread to parts of Hollywood and Santa Monica. One area particularly hard-hit was Koreatown—an ethnic enclave of Korean-owned businesses. On April 30, a dusk-to-dawn curfew was imposed and the National Guard was sent in to put down the rebellion. When it was over 52 people were dead, 2,383 were injured, 16,291 were arrested, and property damage was estimated at between $785 million to 1 billion.[1] While the catalyst of the rebellion was the all-white jury's verdict, the root causes of the civil unrest lie in political, social, and economic conditions in the city of Los Angeles. In spite of its fabled reputation for movie stars, sunny orange groves, and surfers, L.A. suffers from acute problems: in South Central Los Angeles only 45 percent of African-American men are employed, half of the Latinos who live in L.A. are undocumented and "illegal," the drop-out rate for high school students in the city's poorest neighborhoods hovers around 75 percent, and 27 percent of all jobs lost in the nation-wide recession were in the Los Angeles area. In 1992 there were 1100 murders (800 of which were gang-related) in the city.[2] Given such desperate circumstances, it is not difficult to understand why one writer described the rebellion in L.A. as a "wake-up call from urban America."[3]

Since the nineteenth century artists have made the city and urban life a frequent subject. They translated the urban landscape with its grand boulevards teeming with carriages and crowds into deftly painted compositions that captured the energy, style, and frenetic pace of modern life. In their paintings and photographs the city was portrayed on the whole as a place of opportunity, sophistication, and excitement. Today many artists see a different urban reality: the American city plagued by economic devastation, drugs, disease, violence, and substandard housing. This urgent state of affairs has inspired many contemporary artists to turn their attention to the city as a theme as well as a location for their work. Often they are motivated by their desire to make art that works for social change and that is relevant to the people who live in the city. This essay will focus on four artists—John Ahearn, Y. David Chung, the collaborative Group Material, and Krzysztof Wodiczko—whose works observe, reflect, and intervene in the social reality of the urban landscape. Not content to represent the city as merely a conglomeration of tall buildings and busy avenues, they investigate such issues as homelessness, immigration, poverty, racial inequality, and class polarization. Together their different approaches and perspectives provide a key for understanding the character and conditions of the American urban landscape.

Y. David Chung's installation *Turtle Boat Head* creates a scaled-down version of a Korean-owned grocery store similiar to those that exist in poor neighborhoods in cities across the country. Chung's work focuses on the experience of a Korean-American immigrant who operates a store from behind a bullet-proof partition. Chung explains "I wanted to look at

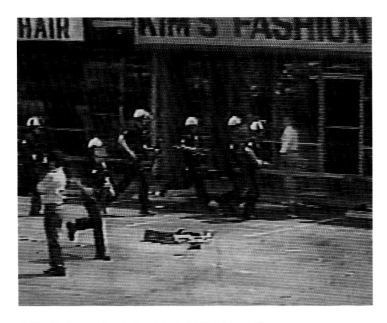

Y. David Chung. *Turtle Boat Head*, 1992. Video still

what life is like for those Koreans who immigrate to this country and open these stores, sometimes in the heart of the inner city, then surround themselves with bars and bullet-proof glass. They don't understand their environment. They lock themselves in these little booths, and people come in and point at things. It's almost as if there are no human beings involved."[4] In recent years Korean-owned businesses have become a focal point for racial confrontation and animosity. Since the shop-owners often live outside the neighborhoods of their stores, the brief exchanges between African-American customers and Korean grocers are sometimes the only interactions between the two ethnic groups. In this context, cultural differences create misunderstanding and suspicion: customers complain that the Koreans do not smile, look them directly in the face, or place change in their hands. Blacks and Latinos living in poor neighborhoods perceive Korean-Americans as "outsiders" who take money, jobs, and businesses away from them. Poverty, frustration, and fear breed violence; for

instance, lyrics in a song by rap musician Ice Cube caution Koreans to "pay respect to the black fist, or we'll burn your store right down to a crisp."[5] Korean-Americans can also be guilty of bigoted thinking and racial violence. Recent immigrants live in close-knit communities and often feel isolated and alienated by language barriers and unfamiliar customs. Fearful of crime and having internalized negative racial stereotypes about African-Americans, they view their customers as potential thieves and hoodlums. For example, in a well-publicized California case in 1991 Soon Ja Du, a Korean merchant, shot a black teenage girl named Latasha Harlins in the back over a disagreement about the price of a bottle of orange juice. Much to the outrage of the black community, the Korean received a six-month suspended sentence with community service and no jail term. Perhaps it is not surprising that Korean businesses were a prime target for black and Latino anger in the Los Angeles uprising. And when the police were slow to move in and protect Koreatown from looters, store owners reportedly took to the rooftops and fired into the crowds.

Chung's artwork explores Korean-American identity in the complicated context of a multiracial, multicultural city. Chung represents the city not as the traditional immigrant "melting pot" but as a place where classes, races, and cultures collide, interact, and form hybrid identities. In its profusion of images *Turtle Boat Head* weaves together a chaotic narrative about the meshing of many cultures, histories, and places. Huge charcoal drawings depict images and narratives from past and present-day Korean history, myth, and culture. Figures and forms are jumbled together in a fantastic mass of images recreating the sense of bewilderment and confusion of the Korean-American immigrant living in a fast-paced modern city. On the painted walls and shelves of the convenience store

Chung depicts the stuff of American consumerism: hamburgers, cigarette lighters, haircare products, football players, scantily clad women, beer and soda, lottery tickets, and condoms. The video tape playing inside the store chronicles the interactions between the grocer and his African-American customers: "Hey Papa-san. . . . How's everything going?. . . Yeah, let me have a pack of Newports and a tall one. . . . I need a quart of milk. . . . Hey you got the sugar back there. . . . Man y'all got everything. . . . You guys gonna be taking over everything soon, huh?" Between customers the Korean grocer daydreams about his childhood in war-time Korea and his present-day life with his family in the suburbs. "What I wanted to show is that when you hear about Korean people in the media, these Korean shop owners, no one knows that many were born and raised during the Japanese occupation and lived through two wars, World War II and the Korean War, and then came to this country."[6] Chung's installation *Turtle Boat Head* creates a sharp focus through which to view the intersection of race and culture in an urban setting. His bulletproof shield becomes a metaphor for the invisible barriers that exist between classes and races—we can see each other but this barrier structures how we interact and communicate with one another. Chung does not offer simple answers or solutions, but he does make it clear that we all live together in this confusing jumble of cultures. His message is of the need for tolerance and greater understanding between the people on both sides of the divide.

The sculptor John Ahearn describes himself as "basically a middle-class, college educated, white, intellectual type."[7] Since 1980 he has lived and worked in the South Bronx. His presence there perplexes his neighbors: some see him as a "saintly" character; others view him with suspicion, wondering why a white guy would choose to live in a neighborhood many of them would leave if given the chance. Ahearn was drawn initially to the South Bronx because he wished to escape the confines of the downtown art world in order to make artwork that was community-based and socially concerned. He says he "gets a tremendous amount of inspiration and energy from the contact [he has] with people in the community."[8] These people are mostly Blacks and Latinos, many

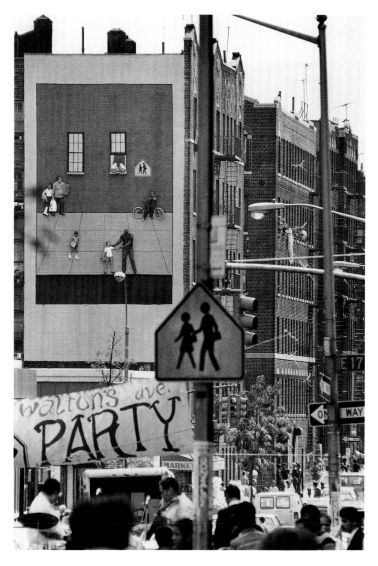

John Ahearn. *Back to School* (Walton Avenue at 172nd Street), 1985.

Party after the Whitney Biennial at the home of Don and Mera Rubell, 1991. Shown left to right: Cast of *Boobie (Sneakertown U.S.A.)* by John Ahearn, 1981; Statue of Liberty sculpture by Keith Haring; painting by Jean-Michel Basquiat

anic, and Titi, who always leans out of her window to survey the comings and goings of the block. In this context Ahearn's works celebrate both the community and its residents.

Ahearn's style of making art requires the consent and cooperation of his neighbors. However, not all of his work is specifically made for the benefit of the South Bronx and its inhabitants. Like most artists, Ahearn needs to sell his work in order to make a living. He is represented by an upscale commercial gallery located on Wooster Street in Soho. The objects he shows and sells there are plaster portrait sculptures of single figures or pairs of people from the South Bronx. Ahearn says that for the most part people from the neighborhood are pleased to have their likenesses on exhibition: "They often think it's glamorous, exciting, that they're presented as stars and they're proud of it. But if someone feels I'm using his image to make money or to go places without him, that might make him upset."[9] The sculptures sold in the gallery are made specifically for the downtown art crowd. They are rendered in a consciously "artful" style in which swatches of unexpected colors—blues, purples, coral tones and deep reds—are applied with loose, expressionistic brush strokes. Ahearn generally produces two different plaster casts of each sitter; one is set aside to be painted later while the other is given to the model and finished in a manner the artist hopes will please the subject. Ahearn explains "portraiture has a lot to do with vanity, with pleasing people. If I'm making something special for one of my models to keep in his own home I might think more about

of whom are recent or illegal immigrants. Beyond its borders, the South Bronx is perhaps best known for its troubles—poverty, crime, and unemployment. The mortality rate has soared since the advent of crack and AIDS. Like any neighborhood the South Bronx is also a place where families struggle to survive, where kids play, and where people fall in love. These are the positive aspects of community life that Ahearn's public art projects reflect back in colorful large-scale murals. They decorate the sides of impoverished apartment buildings with cheerful vignettes: girls skipping rope double dutch-style, a mother and daughter on their way home from shopping and a father walking his son to school. People recognize their friends and relatives in the murals and can identify neighborhood characters such as Pedro Serrano, the local car mech-

what he'd want. It might be designed somewhat differently from the ones I make for myself."[10] Displayed in the South Bronx, Ahearn's sculptures are a portrait of a community and its residents, but in the context of a Soho art gallery or a downtown collector's home the objects acquire different meanings. Ahearn explains, "People sometimes say I'm doing this art for the benefit of people in the Bronx, but I'd like them to realize it's the other way around, that it's for the benefit of the art world, that the art world needs to broaden its horizons, that art itself suffers from its own myopia."[11]

The downtown presentation of the portraits erases the collaborative, social context of the work, leaving Ahearn's black and brown figures looking dramatically isolated and out of place against the white walls of expensive homes and gallery spaces. This sensation of dislocation is compounded by the irony that while the artist can move easily from uptown to downtown and back again, his South Bronx neighbors cannot do the same. Soho may be a mere ten miles away from the South Bronx but it is quite literally another world. To many in the downtown art crowd Ahearn's sculptures represent the world above 125th Street that most have never seen for themselves, but his reaffirming vision of the dignity and strength of the individual masks the cultural, racial, and political specificity of the neighborhood from which the sculptures come and communicates a universalizing message: "we are really all the same." This allows the gallery-goer the comfort of viewing and consuming the work from a privileged and distant location rather than having to question the societal structures and attitudes that leave the citizens of the South Bronx without means, opportunity, or hope.

In 1986 Ahearn received a commission from the Percent for Art Program of the New York City Department of Cultural Affairs to make a public art project for the 44th Precinct police station in the South Bronx.[12] He was selected by a committee of arts experts that included an artist, an arts administrator, a police captain from the precinct, an architect, and the chief curator from the Bronx Museum. Ahearn was chosen on the basis of the positive reception of his previous mural projects and his sustained commitment to the local community. The race and background of the artist were not considered to be a

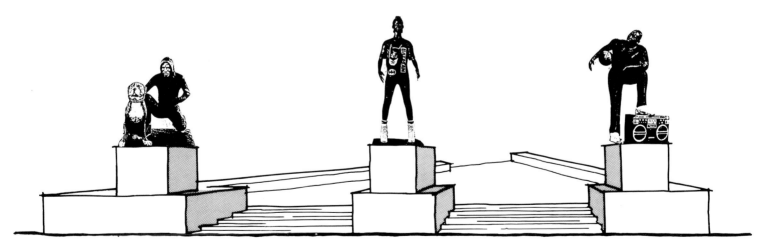

Rendering of Bronx Sculpture Park plan and three painted, cast bronze sculptures: *Raymond* and *Toby*, *Daleesha*, and *Corey*, looking east from Jerome Avenue, 1991

pertinent factors. Ahearn decided to create a public monument with full-length bronze painted portraits of people who lived in the neighborhood. He planned to install it on a triangular plot of land located across the street from the police station. The concept was inspired by the Paseo de la Reforma—a boulevard in Mexico City lined with sculptures of national heroes. However, the people Ahearn chose to represent were not those typically immortalized in bronze or elevated on pedestals. Fourteen-year-old Daleesha came from a troubled family; Corey had trouble keeping a steady job; and Raymond (shown with Toby, his pet pit bull) had been in jail numerous times for drug possession and assault. Ahearn intended for the monument to pay tribute to these three "survivors" (the term he uses) of the neighborhood. Ahearn's unconventional choice of subject matter had even Raymond wondering "What did I do that was so great in this world that they're making me in bronze?"[13] That was also the question a small group of vocal community residents were asking. Ahearn wanted *Daleesha*, *Raymond*, and *Corey* to convey what he calls "the South Bronx attitude" and in proximity to the station house he hoped their presence might "challenge the police" to humanely and fairly treat even the neighborhood's most troubled residents. However, to some, Ahearn's choice of subjects seemed to imply that they were the best the community had to offer, and that the art "glorified" the failures of the neighborhood. A woman named Alcina Salgado whose apartment looked out over the triangle did not like the statues because they looked like the kind of people that smoked crack, hung out, and made trouble for the "good" people in the neighborhood. Several residents pointed out that the monument seemed to endorse rather than to challenge prevailing stereotypes. One woman called the figures "totems of racism," characterizing *Corey* and *Raymond* respectively as "a shiftless fat slob with a boom box" and "a junkie with a dog."[14] Suggestions for more "suitable" subjects

were offered: Martin Luther King, Malcolm X, school kids in graduation gowns, friendly cops helping folks across the street, and professionally dressed men on their way home from downtown jobs. On September 30, 1991, just five days after the cranes lifted the sculptures onto their pedestals, Ahearn bowed to the protesters and removed the sculptures from their concrete plinths. Ahearn explains: "What I felt was, I had a choice. I didn't want trouble. I knew the news people would be down. Imagine—all these nice ladies crying on television! I thought I'm not going to win this."[15] The controversy that surrounds the 44th Precinct police station commission tells us something about the difficulty and complications in making art that purports to "speak" for or "represent" the social reality of any neighborhood or community. Because of his own racial and class background Ahearn was especially vulnerable to this criticism, but in the end it is not certain whether a black or Latino artist could have created a more truthful community portrait. Perhaps the failure of Ahearn's project lies in its "in your face" presentation of one segment of a diverse and multicultural city neighborhood. A monument is a polemical and static representation that authorizes and over determines its own meaning. It can neither encompass nor take into account the full complexity of urban reality. The true picture of the South Bronx is constantly unfolding, an ever-evolving dialogue between many divergent, inconsistent, and sometimes contradictory opinions and perspectives.

The artists' collaborative Group Material takes their art practice into the streets of the city. They seek direct engagement with the heterogeneous population of the modern city through exhibitions, installation projects, and "town meetings "—open forums on various social topics organized and advertised by the collective. In the town meetings, for example, the public is invited to participate in discussion with the artists, community

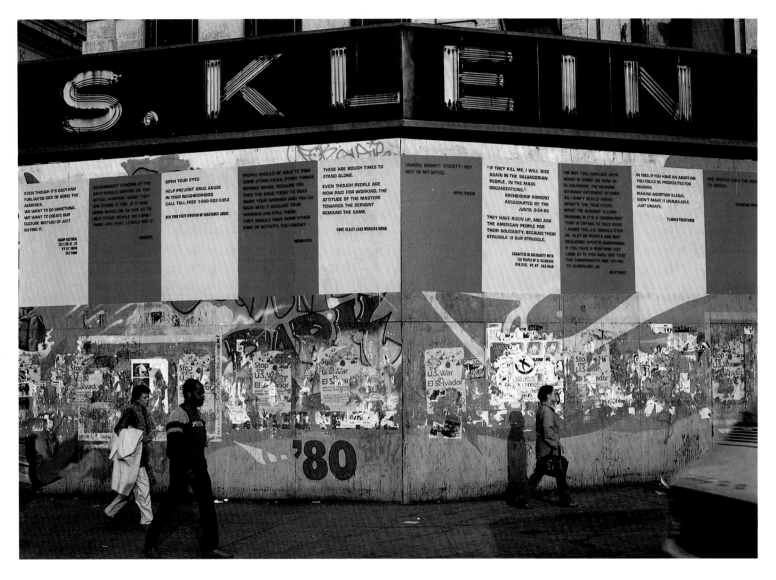

activists, and critical theorists. Initially, the collective operated a storefront space in the ethnically diverse neighborhood of Manhattan's East Village, where they mounted exhibitions around issues of importance to the immediate community. In some cases their neighbors were invited to participate in the selection and creation of objects to be exhibited in the gallery. Over the years the group's mission has emphasized accessibility and content over traditional concerns about art history and art making. "Our exhibitions and projects are intended to be

Group Material. *DA ZI BAOS*, 1982. Union Square, New York City. Ink on paper. 8 x 60 feet

forums in which multiple points of view are represented in a variety of styles and methods. We believe, as the femininst writer bell hooks has said, that 'we must focus on a policy of inclusion so as not to mirror oppressive structures'."[16]

In 1982 the Group Material created a project they entitled "DA ZI BAOS." In China, *da zi bao* are posters made by indi-

vidual citizens to express their reactions to organized politics. They are posted in public spaces such as on the long brick wall near Tiananmen Square that came to be known popularly in China and abroad as the "Democracy Wall." Group Material installed their *DA ZI BAOS* project on a defunct department store near Union Square because it and the surrounding area were slated to be transformed by urban redevelopment and gentrification. Historically Union Square had been an intersection of many different classes and cultures, but in the mid-1980s the interests of wealthy real estate developers seemed to have won when the city closed down the square above 14th Street during the construction of a gigantic luxury apartment building called Zeckendorf Towers at its southeast corner.[17] Group members illegally pasted up brightly colored red and yellow posters containing statements from various political and social organizations as well as from individuals they interviewed around the square. On a symbolic level *DA ZI BAOS* laid claim to the public space of the street in the name of the various constituencies whose voices and perspectives it contained. It also created a critical framework through which to view the forces of private enterprise and capitalism that were working to refigure the social fabric of the entire surrounding area. After *DA ZI BAOS* the collective created several similar projects called "Democracy Walls" — displays that featured large-scale colored placards containing a range of views culled from interviews done in and around the site where they were installed. These projects offered a flexible format to represent what the Group terms an "opinion landscape." By utilizing a method of inclusion and plurality the collective is able to portray a given theme or issue in a complex way. They do not censor or smooth over unruly, diverse differences of opinion in the interests of maintaining political correctness or avoiding controversy. For example, in Cardiff, the capital of Wales, the collective produced a Democracy Wall (1985) focusing on the

family. It featured responses from a housewife, a family planning association, a well-known actor, as well as remarks from two right-wing political groups, the National Front and the National Cleansing Campaign. The Group was reluctant to censor the fascist views and so included them in the installation, but shortly afterwards both posters containing the inflammatory remarks were torn down from the wall of the community center that hosted the project. Whether on a crowded city street or on the façade of an art museum, a Democracy Wall simultaneously articulates a site and the social conditions that encompass and create it. It is always intended to represent a range of popular opinion and to foster debate. "We are not interested in making definitive evaluations or declarative statements, but in creating situations that offer our chosen subject as a complex and open-ended issue," wrote Group Material recently. "We encourage greater audience participation through interpretation."[18]

Krzysztof Wodiczko argues that traditional city monuments, war memorials, and commemorative sculpture serve to decorate, embellish, and mask the ideological underpinnings of the urban landscape. They are what he terms "bureaucratic-aesthetic environmental pollution." Wodiczko formulated this critique during the 1980s "boom" in public art commissions. In New York, a great many public works were paid for by a new program called Percent for Art, which stipulated that every public construction project in the city set aside one percent of its budget to purchase art. Ahearn's Bronx sculpture project was funded by this program, as were numerous other public art projects in such locations as Battery Park and the Lower East Side. While the initiative was welcomed by arts administrators and public officials alike, there were some who questioned the integrity of the relationship between public art and urban redevelopment and specifically the way in which art

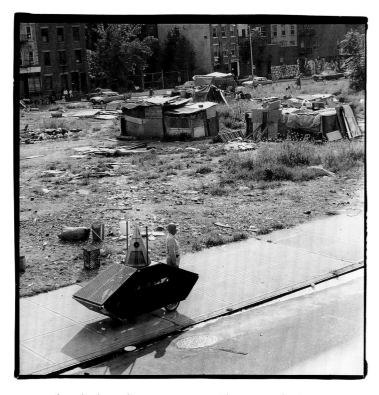

Krzysztof Wodiczko. *Poliscar*, Lower East Side, New York City, 1992

was being used to create the illusion that the for-profit development plans were socially and culturally beneficial. In a now classic essay entitled "Uneven Development: Public Art in New York City" Rosalyn Deutsche criticized this tendency to celebrate public art without acknowledging or interrogating the specific circumstances that made it possible: "As a practice within the built environment, public art participates in the production of meanings, uses, and forms for the city. In this capacity, it can help secure consent to redevelopment and to the restructuring that make up the historic forms of late capitalist urbanism."[19] However, she goes on to point out that "like other institutions that mediate perceptions of the city's economic and political operations—architecture, urban planning, urban design—[art] can also question and resist those operations." Wodiczko's early slide projections confirm

Deutsche's latter point: a good example is his 1984 piece in which he projected the image of two padlocks and chains on the front and side of the Astor Building on Broadway. The New Museum of Contemporary Art occupied the ground floor and the basement of the Astor building, paying a very low rent, while the upper floors remained empty until they were brought by wealthy investors at a cool million dollars each. Wodiczko's vision of the locked-up building exposed the high social cost of real estate speculation in a city with an exploding homelessness problem. Furthermore, it revealed the way that art created an aura of style and culture that allowed the owners of the building to turn a handsome profit on their so-called philanthropic enterprise of supporting the arts.

Wodiczko's work teases, beguiles, and intrigues. It often embodies contradictory or multiple purposes that the artist refuses to simply or clarify. This complexity is especially evident in *Poliscar*. As a form of public address the work is confrontational, even alarming to some viewers. Critics have variously compared it to an armored tank, a space vehicle, and a child's wind-up toy. It takes its title from the Greek word *polis* meaning city, playing on its double meaning, referring to the actual city as well as the state of a collective society or community. Wodiczko has argued that the city or "polis" is a crowded place full of many loud voices—architecture, sculptures and monuments, advertisements. However, the homeless do not have access to this so-called public forum despite the fact that public discourse goes on all around them. To that end, *Poliscar* is intended to provide the homeless with some means of participating in public life by enabling them to speak to each other and to non-homeless. Communications linkage between the homeless would allow for the dissemination of important information on a variety of topics: evictions, elections, employment, legal aid, medical advice, and entertain-

ment. Wodiczko envisions networks of *Poliscars* in one part of the city using satellite base stations to transmit to encampments of evicts in other parts of the city. These vehicles would also allow the homeless to organize as a community in order to counteract the isolation and disenfranchisement experienced by individuals living out on the streets. Like the covered wagons of the American West, each individual vehicle is designed to attach to its neighbor for the purposes of protection, strategic planning, and socializing.

Wodiczko first presented his *Poliscar* in a squatters' settlement close to Tompkins Square Park in New York City. The majority of the people living in this settlement had been evicted the previous year from the park after a highly publicized violent struggle against the combined forces of developers, politicians, and police. Beginning in the mid-1980s, many Lower East Side tenement buildings were transformed into expensive condominiums, thereby displacing hundreds of apartment dwellers

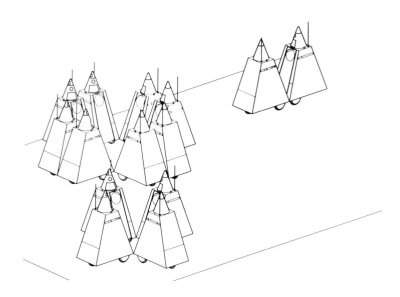

Krzysztof Wodiczko. Drawing for *Poliscar*, 1991. Ink on paper. 24 x 36 inches. Courtesy of Galerie Lelong

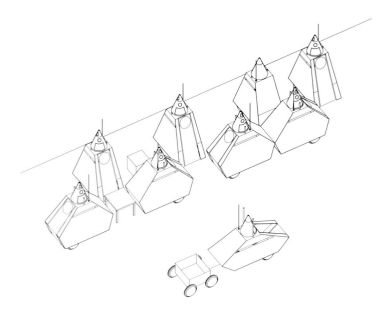

Krzysztof Wodiczko. Drawing for *Poliscar*, 1991. Ink on paper. 24 x 36 inches. Courtesy of Galerie Lelong

and squatters into the nearby streets and into Tompkins Square Park where they set up crudely built shacks and tents. In 1988 the police stepped up their efforts to control the noise, drug activity, and homeless population in the park by imposing a curfew. The people living in the park angrily demonstrated against the police action, shouting slogans like "Die Yuppie Scum" and "Gentrification Equals Class War."[20] Protests and clashes with the police culminated three years later on September 15, 1991, when police moved in with bulldozers and riot gear. It was in this context that Wodiczko introduced his vehicle, making it impossible to overlook the similarities between the words "Poliscar" and "police car." For Wodiczko, the squatters living in this settlement were the ideal *Poliscar* operators: they had demonstrated their ability to organize and mobilize against the forces that threatened their home. In related drawings and sketches for *Poliscar* Wodiczko shows viglilante vehicle operators engaged in armed standoffs with police. In this sense *Poliscar* was conceived and

designed as a "response to the image of the contemporary city, which the uniformed police and real estate armies have made a militarized zone."[21] Wodiczko ominously refers to these scenarios as a kind of "warning about the future of the present."

Only two *Poliscar*s have been built thus far, so the artist's vision of networks of vehicles exists only in his drawings. Even stand-offs between police and evicts are but a theoretical possibility since *Poliscar*'s "armored" walls are made of cloth and offer no real protection. Perhaps the vehicle's most important function lies in its startling ability to engage an audience, to convey information, and to test ideas. Thus, *Poliscar* highlights the personal and community isolation experienced by individuals living on the street. Its conspicuous weirdness embodies the alienation that results from "being in the midst of things without being able to take part in them, being displaced from the very place where you are present."[22] Whether encountered on a city street or in the Museum of Fine Arts, Boston, *Poliscar* operates first and foremost as a metaphoric vehicle, reflecting Wodiczko's belief that "democracy, like liberty, is a practice not something conferred on us." For him, "art as a voice and a message is an important way of practicing democracy in public places. Understood this way, critical active art helps keep democracy alive."

■ ■ ■

In the days that followed the Los Angeles uprising there were many promises and plans made to try to improve conditions in the city. A year later little has been done. Media attention is now focused elsewhere and many of the city's wealthier and more influential residents are giving up on it. Some residents have even lobbied the city to have their public streets barricaded or closed off while others are arming themselves for the

Y. David Chung. *Turtle Boat Head*, 1992. Video still

next riot. Sadly, the rebellion that began as a protest against police brutality has resulted in even more stringent control of the city and its so-called unruly residents. In this regard the recent election of a mayor who campaigned on a "law and order" platform does not bode well.[23] A mind-boggling expression of this ambivalence toward the city is to be found in a theme park, called "City Walk," which opened recently in Los Angeles. City Walk is a $100 million project that presents the "experience" of L.A. in four blocks of trendy stores and restaurants. Architects and designer carefully reproduced "authentic local flavor" with Spanish and art deco building façades, freeway signs, and even a wave machine to remind visitors of the famous L.A. coast. One restaurant installed an artificial beach complete with trucked-in sand, imported palm trees, and regularly scheduled volleyball games and wet–T-shirt contests. This spiritual heir to Disneyland has been in the works for about ten years, but its popular draw, especially with the out-of-town tourists, is undeniably linked to the violence and

unglamorous problems of the real L.A. In contrast to the actual city, City Walk promises to be a well managed, safe, and beautiful environment—a drug-free, homeless-free, gang-free, poverty-free zone (the only factor not successfully eliminated was smog). Most visitors seemed satisfied with the City Walk experience; one woman said "this is great, but then we have nothing to compare it with. We've never been to L.A."[24] There is a bitter irony in the creation of an idealized multimillion-dollar version of the "City of Angels" when inner-city neighborhoods torn about by the riot cannot attract the private investment necessary to rebuild themselves. According to the Deputy Mayor of Los Angeles, "People in Los Angeles have not adjusted to the notion of Los Angeles having become a major world city with all the problems that brings."[25] It seems certain that, if we Americans are unwilling to face the challenges and issues brought forth in L.A. and in cities across the nation, anger will once again fuel the fires because to paraphrase the Los Angeles protestors, "without justice there will be no peace."

KATHRYN POTTS

NOTES

1. Statistics as cited in Melvin L. Oliver, James H. Johnson, Jr., and Walter C. Farrell, Jr., "Anatomy of a Rebellion: A Political-Economic Analysis," in *Reading Rodney King/ Reading Urban Uprising*, ed. Robert Gooding-Williams (New York & London: Routledge, 1993), p. 121.

2. Statistics as cited in Mark Cooper, "Falling Down," *Village Voice*, March 23, 1993, p. 25.

3. Haki R. Madhuburti, Introduction, to *Why L.A. Happened: Implications of the 92 L.A. Rebellion*, ed. Haki R. Madhuburti (Chicago: Third World Press, 1993), xv.

4. Y. David Chung as cited in Patricia Smith, " 'Crazy piece of theater' confronts black-Korean tension," *Boston Globe*, April 3, 1992, p. 98.

5. As cited in Sumi K. Cho, "Korean Americans vs. African Americans: Conflict and Construction," *Reading Rodney King/ Reading Urban Uprising*, ed. Robert Gooding-Williams (New York & London: Routledge, 1993), p. 201.

6. Y. David Chung, interview with Philip Brookman, as cited in Philip Brookman, "From World Wars to Convenience Stores: Dreams of History in Y. David Chung's *Turtle Boat Head*," *Turtle Boat Head*, exhibition brochure (New York: Whitney Museum of American Art at Philip Morris, 1992), unpaginated.

7. John Ahearn interviewed in "The Sculptor's 'Models Are the Stars'," *New York Newsday*, March 6, 1991, p. 99.

8. John Ahearn interviewed in Grace Glueck, "An Immovable Feast: Murals in the City," *New York Times*, July 22, 1988, section C, p. 28.

9. "The Sculptor's 'Models Are the Stars," p. 100.

10. Ibid.

11. Ibid.

12. For an excellent discussion of John Ahearn's work and the Bronx sculpture commission see Jane Kramer, "Whose Art is it?," *New Yorker*, December 21, 1992, pp. 80-109.

13. Raymond Garcia as cited in Richard Goldstein, "The Headhunters of Walton Avenue," *South Bronx Hall of Fame: Sculture by John Ahearn and Rigoberto Torres* (Houston: Contemporary Arts Museum, 1991), p. 81.

14. As cited in Kramer, "Whose Art?," p. 101.

15. Ibid., 100.

16. Group Material, "On Democracy," in Dia Art Foundation, *Democracy: A Project by Group Material*, Discussions in Contemporary Culture, vol. 5, Brian Wallis, ed. (Seattle: Bay Press, 1990), p. 2.

17. Martha Rosler, "Tompkins Square Park, East Village, Lower East Side, Manhattan, New York," in Dia Art Foundation, *If You Lived Here: The City in Art, Theory, and Social Activism: A Project by Martha Rosler,* Discussions in Contemporary Culture, vol. 6, Brian Wallis, ed. (Seattle: Bay Press, 1991), p. 211.

18. Group Material, "On Democracy," *Democracy*, p. 2.

19. Rosalyn Deutsche, "Uneven Development: Public Art in New York City," *October* 47, winter 1988, p. 10.

20. Martha Rosler, "Tompkins Square Park," *If You Lived Here*, pp. 212-216.

21. Bruce W. Ferguson, "A Conversation with Krzysztof Wodiczko," *Krzysztof Wodiczko: Instruments, Projeccions, Vehicles*, ed. Manuel J. Borja-Villel, exhibition catalogue (Barcelona: Fundació Antoni Tàpies, 1992), p. 63.

22. Yves Michaud, "Perfecting, Disturbing and Displacing," *Krzysztof Wodiczko: Instruments, Projeccions, Vehicles*, ed. Manuel J. Borja-Villel, exhibition catalogue (Barcelona: Fundació Antoni Tàpies, 1992), p. 41.

23. See Cooper, "Falling Down ," *Village Voice*, pp. 25-29.

24. As cited in Phillipp M. Gollner, "Mall That Imitates Life," *New York Times*, June 27, 1993, sec. 9, p. 3. I am indebted to Joellen Masters for bringing this article to my attention and for giving me valuable criticism and advice on this essay.

25. Ibid.

CHECKLIST

John Ahearn
American, born 1951

Raymond and Freddy, 1992 (p. 13)
Acrylic on cast plaster
32½ x 24 x 9¾ inches
Museum of Fine Arts, Boston
Purchased through funds provided by AT&T NEW
ART/NEW VISIONS and the William E. Nickerson
Fund 1993.183

Samson, 1990–92 (p. 14)
Oil on fiberglass
62 x 46½ x 13 inches
Collection of Dr. Gerald and Phyllis Seltzer,
Cleveland

Takiya, 1990 (p. 10)
Acrylic on cast plaster
25 x 18 x 7½ inches
Courtesy of Brooke Alexander, New York

Corey, 1988
Acrylic on cast plaster
75 x 40 x 32 inches
Collection of the artist

Luis and Virginia Arroyo, 1980
Acrylic on cast plaster
24 x 24½ x 7 inches
Collection of the artist

Janice Parsons, 1979
Acrylic on cast plaster
15 x 12 x 7 inches
Collection of the artist

Johnny, 1979
Acrylic on cast plaster
16 x 12 x 6 inches
Collection of the artist

*South Bronx Hall of Fame: Sculpture by John
Ahearn and Rigoberto Torres,* 1991
Video
English with Spanish subtitles
Produced by Bill Howze for Contemporary Arts
Museum, Houston

Tina Barney
American, born 1945

Thanksgiving, 1992 (p. 21)
Chromogenic color print (Ektacolor)
49¾ x 62½ inches
Museum of Fine Arts, Boston
Contemporary Curator's Fund, including funds
provided by Barbara and Thomas Lee 1993.187

The Floor, 1992 (p. 22)
Chromogenic color print (Ektacolor)
48 x 60 inches
Courtesy of Janet Borden, Inc., New York

Mrs. Barney, 1991 (p. 18)
Chromogenic color print (Ektacolor)
60 x 48 inches
Courtesy of Janet Borden, Inc., New York

The Boys, 1990 (p. 22)
Chromogenic color print (Ektacolor)
48 x 60 inches
Museum of Fine Arts, Boston
Contemporary Curator's Fund, including funds
provided by Barbara and Thomas Lee 1993.186

The American Flag, 1988 (p. 23)
Chromogenic color print (Ektacolor)
48 x 60 inches
Courtesy of Janet Borden, Inc., New York

The Portrait, 1984 (p. 63)
Chromogenic color print (Ektacolor)
48 x 60 inches
Collection of J. Michael Parish

Diane, Mark, and Tim, 1982
Chromogenic color print (Ektacolor)
46 x 59 inches
Collection of Evelyn D. Farland

All photographs printed in editions of 10.

David Bates
American, born 1952

Baits, 1990 (p. 24)
Oil on canvas
84 x 64 inches
Private Collection

Red Fish, 1990
Oil on canvas
60 x 36 inches
Private Collection

The Cleaning Table, 1990 (p. 31)
Oil on canvas
84 x 64 inches
The Barrett Collection, Dallas, Texas

Matagorda Bay, 1989 (p. 29)
Oil on canvas
60 x 72 inches
Collection of Sondra Gilman and Celso Gonzalez-
Falla

A Warm Day in a Cool Month, 1987 (p. 28)
Oil on canvas
60 x 48 inches
Stuart Handler Family Collection, Evanston,
Illinois

Kingfisher, 1985 (p. 28)
Oil on canvas
96 x 78 inches
Collection of Laila and Thurston Twigg-Smith

Y. David Chung
American, born in Bonn, Germany, 1959

Turtle Boat Head, 1992 (pp. 36–39, 66, 72,
74, 83)
Charcoal on paper, wood, video projection
Storefront Structure: Height 8 feet
Mirror Box: Height 6 feet slanting to 4 feet
Vestibule Area: 9 feet x 6 feet
Videography: Matt Dibble
Construction Design: Luke Mandle
Sound: Pooh Johnston
Voices: African Continuum Theater Coalition,
Washington, D.C.
Special thanks to Choong Choi and family

Group Material
Artists' Collaborative
American, founded 1979

Democracy Wall, 1993 (p. 46–47)
Temporary installation at Museum of Fine Arts,
Boston
Paint on plywood
10 x 77 feet
Funded in part by the Charles Engelhard
Foundation

Untitled, 1991 (p. 45)
Bus placard
1 of 50
21⅛ x 70⅛ inches
Museum of Fine Arts, Boston
Museum Purchase 1991.474

Shopping Bag, 1989
Printed polyurethane shopping bag
Unlimited edition
17½ x 14 inches

Inserts, 1988
Advertising supplement to *The New York Times*,
May 22, 1988
10⅝ x 8 inches
Sponsored by the Public Art Fund Inc. with the
generous support of the New York State Council
on the Arts, and Art Matters, Inc.

AIDS Timeline, 1990
December issues of nationally distributed art
magazines containing Group Material "Day
Without Art" insert

Krzysztof Wodiczko
Polish, Canadian; born in Warsaw, Poland,
1943

Poliscar, 1991 (pp. 54, 55, 67, 81)
Steel, fabric, wood, motorcycle engine, television
monitor with video player, radio equipment on
wheels
122½ x 73 x 49 inches (upright position with
antennae in place)
Courtesy of Galerie Lelong
This project originated as a proposal for the city
of Cambridge, commissioned by the Cambridge
Arts Council, Massachusetts, and received further
assistance for the development of *Poliscar* from
the Musée d'Art Contemporain, Montréal,
Canada, and Josh Baer of the Josh Baer Gallery,
New York.

Nine drawings for *Poliscar*, 1991

Graphite on vellum (p. 67)
54½ x 34⅜ inches
Collection of The Linc Group, Chicago

Graphite on vellum
54½ x 34⅜ inches
Collection of The Linc Group, Chicago

Graphite on vellum (p. 9)
30 x 53 inches
Courtesy of Galerie Lelong

Graphite on vellum
30 x 53 inches
Courtesy of Galerie Lelong

Graphite on vellum
30 x 53 inches
Courtesy of Galerie Lelong

Graphite on vellum
30 x 53 inches
Courtesy of Galerie Lelong

Ink on paper (p. 82)
24 x 36 inches
Courtesy of Galerie Lelong

Ink on paper (p. 82)
24 x 36 inches
Courtesy of Galerie Lelong

Graphite on vellum
18⅛ x 101 inches
Courtesy of Galerie Lelong

SELECTED BIBLIOGRAPHY

John Ahearn

De Ak, Edit. "John Ahearn's 'We Are Family' in the South Bronx." *Artforum* 21 (November 1982), pp. 73-74.

Deitch, Jeffrey. "Report From Times Square." *Art in America* 68 (September 1980), pp. 58-63.

Goldstein, Richard; Ventura, Michael; and Zeitlin, Marilyn A. *South Bronx Hall of Fame—Sculpture by John Ahearn and Rigoberto Torres.* Exhibition catalogue. Houston: Contemporary Arts Museum, 1991.

Jarmusch, Ann. "John Ahearn and Rigoberto Torres: Sculpture for Change." *John Ahearn with Rigoberto Torres: Sculpture.* Exhibition catalogue. Philadelphia: Institute of Contemporary Art, University of Pennsylvania, 1986.

Robinson, Walter. "John Ahearn at Fashion/Moda." *Art in America* 68 (January 1980), p. 108.

Tina Barney

Gamerman, Amy. "Tina Barney Takes Aim at the Big Board." *Wall Street Journal*, April 27, 1993, p. A18.

Grundberg, Andy. "Tina's World: In Search of the Honest Moment." *New York Times*, April 1, 1990, pp. 39-41.

Rimanelli, David. "People Like Us: Tina Barney's Pictures." *Artforum* 31 (October 1992), pp. 70-73.

Rubinstein, Meyer Raphael. "Life Styles of the Protestant Bourgeoisie: The Photographs of Tina Barney." *Arts Magazine* 62 (April 1988), pp. 50-52.

Sullivan, Constance, and Weiley, Susan, ed. *Friends and Relations: Photographs by Tina Barney.* Washington and London: Smithsonian Institution Press, 1991.

David Bates

Gallati, Barbara Dayer. "Reconciling Place and Process: New Chapters in the Art of David Bates." *David Bates*. Exhibition catalogue. Miami: The Art Museum at Florida International University, 1993.

Hill, Ed, and Bloom, Suzanne. "David Bates at the Texas Gallery, Houston." *Artforum* 23 (November 1984), p.108.

Nash, Steven A. "David Bates Then and Now." *David Bates: Recent Paintings and Works on Paper.* Exhibition catalogue. San Francisco: John Berggruen Gallery, 1989.

Pillsbury, Edmund P. "David Bates: A Painter's Painter." *David Bates: Recent Work*. Exhibition catalogue. San Francisco: John Berggruen Gallery, 1992.

Price, Marla. "Finding a Place: The Recent Paintings of David Bates." *David Bates: Forty Paintings*. Exhibition catalogue. Fort Worth: The Modern Art Museum of Fort Worth, 1988.

Y. David Chung

Brookman, Philip. "From World Wars to Convenience Stores: Dreams of History in Y. David Chung's *Turtle Boat Head.*" *Turtle Boat Head.* Exhibition brochure. New York: Whitney Museum of American Art at Philip Morris, 1992.

Davenport, Kimberly. "Interview with Y. David Chung." *MATRIX 121*. Exhibition brochure. Hartford: Wadsworth Atheneum, 1993.

Fleming, Sherman. "The 'Cut/Across' Performances." *High Performance* 43 (fall 1988), p. 37.

Machida, Margo. *Angulas—Street of Gold.* Exhibition catalogue. New York: Jamaica Arts Center, 1990.

Mandle, Julia Barnes, and Rothschild, Debra Menaker. *Sites of Recollection: Four Altars & a Rap Opera.* Exhibition catalogue. Williamstown, Massachusetts: Williams College Museum of Art, 1992.

Stiles, Kristine. "Not Just an 'Other' Exhibition: 'Cut/Across' at WPA Examines Art and Racism." *High Performance* 43 (fall 1988), pp. 34-38.

Group Material

Berkson, Bill. "AIDS Timeline at the University Art Museum, Berkeley." *Artforum* 28 (March 1990), pp. 168-169.

Dia Art Foundation. *Democracy: A Project by Group Material.* Discussions in Contemporary Culture, vol. 5, Brian Wallis, ed. Seattle: Bay Press, 1990.

Lawson, Thomas. "Group Material's 'The People's Choice'." *Artforum* 19 (April 1981), pp. 67-68.

Kuspit, Donald; Ratner, Michael; Ratner, Margaret; and Wright, Honorable Bruce McM. *Constitution*. Exhibition catalogue. Philadelphia: The Temple Gallery, 1987.

Olander, William. "Material World." *Art in America* 77 (January 1989), pp. 123-167.

Krzysztof Wodiczko

Borja-Villel, Manuel J., ed. *Krzysztof Wodiczko: Instruments, Projeccions, Vehicles.* Exhibition catalogue. Barcelona: Fundacio Antoni Tapies, 1992.

Deutsche, Rosalyn. "Uneven Development: Public Art in New York City." *October* 47 (winter 1988), pp. 3-52.

Poliscar. Exhibition catalogue. New York: Josh Baer Gallery, 1991.

Dia Art Foundation. *If You Lived Here: The City in Art, Theory, and Social Activism: A Project by Martha Rosler.* Discussions in Contemporary Culture, vol. 6, Brian Wallis, ed. Seattle: Bay Press, 1991.

Wodiczko, Krzysztof, and Lurie, David. *The Homeless Vehicle Project.* ArT RANDOM Series, no. 81. Kyoto: Kyoto Shoin International, 1991.

Photograph and Illustration Credits

Frontispiece

Page 2: Shane Newmark, courtesy of the 42nd Street Art Project

Preface

Page 9: Department of Photographic Services, Museum of Fine Arts, Boston; courtesy of Galerie Gabrielle Maubrie, Paris

Ahearn

Page 10: D. James Dee, courtesy of Brooke Alexander, New York

Page 12: Jeannette Montgomery Barron, courtesy of Brooke Alexander, New York

Page 13: Department of Photographic Services, Museum of Fine Arts, Boston

Page 14: D. James Dee, courtesy of Brooke Alexander, New York

Page 15: Martha Cooper, courtesy of Brooke Alexander, New York

Page 16: Ivan Dalla Tana, courtesy of Brooke Alexander, New York

Page 17: (top and bottom left) John Ahearn, (top right) Ivan Dalla Tana; all courtesy of Brooke Alexander, New York

Barney

Page 18: courtesy of Janet Borden, Inc., New York

Page 20: courtesy of Janet Borden, Inc., New York

Page 21: Department of Photographic Services, Museum of Fine Arts, Boston

Page 22: (top) Department of Photographic Services, Museum of Fine Arts, Boston; (bottom) courtesy of Janet Borden, Inc., New York

Page 23: courtesy of Janet Borden, Inc., New York

Bates

Page 24: Department of Photographic Services, Museum of Fine Arts, Boston

Page 26: Shawn Michael Lowe, courtesy of the artist

Page 27: (left) courtesy of New Orleans Museum of Art; (right) David Wharton, courtesy of the Modern Art Museum of Fort Worth

Page 28: (left) Lee Fatherree, courtesy of the artist; (right) David Wharton, courtesy of the Modern Art Museum of Fort Worth

Page 29: courtesy of John Berggruen Gallery, San Francisco

Page 30: (top two) Department of Photographic Services, Museum of Fine Arts, Boston; (bottom two) David Bates

Page 31: Lee Clockman, courtesy of the artist

Chung

Page 32: Claudio Vazquez, courtesy of the artist

Page 33: Claudio Vazquez, courtesy of the artist

Page 34: Charlotte de Azcarate, courtesy of the artist

Page 35: Claudio Vazquez, courtesy of the artist

Page 36: (top and bottom) Department of Photographic Services, Museum of Fine Arts, Boston

Page 37: Department of Photographic Services, Museum of Fine Arts, Boston

Page 38: Department of Photographic Services, Museum of Fine Arts, Boston

Page 39: Department of Photographic Services, Museum of Fine Arts, Boston

Group Material

Page 40: Mundy McLaughlin, courtesy of Group Material

Page 42: Ben Blackwell, courtesy of Berkeley University Art Museum and Group Material

Page 43: (left) Department of Photographic Services, Museum of Fine Arts, Boston, courtesy Bethany Johns Design, New York; (right) Ben Blackwell

Page 44: Evan Estern, courtesy of Real Art Ways and Group Material

Page 45: (top and bottom) Department of Photographic Services, Museum of Fine Arts, Boston

Wodiczko

Page 48: courtesy of Galerie Lelong, New York

Page 49: Jagoda Przybylak, courtesy of Galerie Lelong, New York

Page 50: Elzbieta Tejchman, courtesy of Galeria Foksal, Warsaw

Page 51: courtesy of Galerie Lelong, New York

Page 52: Krzysztof Wodiczko, courtesy of Galerie Lelong, New York

Page 54: (top and bottom) John Ranard

Page 55: Jagoda Przybylak, courtesy of the Walker Art Center, Minneapolis

Fairbrother Essay

Page 56: Nina Berman, courtesy of Sipa Press, New York

Page 58: (top) drawing by D. Reilly © 1993, courtesy of The New Yorker Magazine, Inc.; (bottom) Nina Berman, courtesy of Sipa Press, New York.

Page 61: Department of Photographic Services, Museum of Fine Arts, Boston

Page 63: courtesy of Janet Borden, Inc., New York

Page 64: Ivan Dalla Tana, courtesy of Brooke Alexander, New York

Page 66: Department of Photographic Services, Museum of Fine Arts, Boston

Page 67: (top) courtesy of Fundació Antoni Tàpies, Barcelona; (bottom) John Ranard

Page 69: Department of Photographic Services, Museum of Fine Arts, Boston

Potts Essay

Page 72: Department of Photographic Services, Museum of Fine Arts, Boston

Page 74: Department of Photographic Services, Museum of Fine Arts, Boston

Page 75: Ivan Dalla Tana, courtesy of Brooke Alexander, New York

Page 76: courtesy of Brooke Alexander, New York

Page 77: drawing/montage by Don Quaintance, courtesy of Public Address Design, Houston

Page 79: Mundy McLaughlin, courtesy of Group Material

Page 81· John Ranard

Page 82: (top and bottom) courtesy of Fundació Antoni Tàpies, Barcelona

Page 83: Department of Photographic Services, Museum of Fine Arts, Boston